the **digital photographer's** handbook

# special effects

retouching and restoration

RotoVision

A RotoVision Book
Published and distributed by RotoVision SA
Route Suisse 9, CH-1295 Mies
Switzerland

RotoVision SA, Sales, Editorial & Production Office
Sheridan House, 112/116a Western Road
Hove BN3 1DD, UK

Tel: +44 (0)1273 72 72 68
Fax: +44 (0)1273 72 72 69
Email: sales@rotovision.com
Website: www.rotovision.com

10 9 8 7 6 5 4 3 2 1

ISBN 2-88046-753-5

Edited by Leonie Taylor

Designed by Fineline Studios

Reprographics in Singapore by Provision Pte. Ltd.
Printed and bound in Singapore by Provision Pte. Ltd.

# CONTENTS

# Introduction

With all the advantages digital photography gives to the budding photographer, there's still plenty of opportunity for making mistakes. No matter how much you spend on a digital camera, scanner, or software, you'll always need to make adjustments and enhancements to draw the very best out of your image files. Just as an original film negative is interpreted in the darkroom, or a pianist interprets a musical score, a digital file needs careful processing to achieve the best results. This book is designed to help solve all common imaging problems, and also to guide your creative instincts.

We've all got average photographs which could be great if we'd only concentrated a bit more at the time of shooting. Composition and exposure are two aspects of photography that can sometimes be overlooked in the heat of the moment. Yet, once captured and previewed later on, there's always something that could have been better.

All software programs offer quick-fix commands for making brighter, sharper, or more colorful images, but rarely do they help you achieve maximum print quality. This book sets out all the most important commands and processing sequences

▲ **above:** Add creative edges to your images, page 100

▲ **top:** Make low-contrast prints, page 64

▲ **above:** Add color to your images, page 72

to help you revive your images and produce top-quality results. With an in-depth look at fixing both shooting and scanning mistakes, together with instructions for repairing damaged originals of all kinds and ages, this book aims to be an essential reference for the busy photographer using digital processing technology.

Rescue, repair, and restoration are all hard-won skills central to the practice of a traditional professional darkroom, and enable the very best to conjure up wonderful prints out of decidedly poor-quality originals. With step-by-steps which lead you

through fixing both simple and complex problems, no prior knowledge of Photoshop is assumed. Starting with simple edits and time-saving commands, each project will show the correct way of enhancing your image without damaging it beyond repair.

With tips and hints for making Photoshop work better for you, and jargon-free descriptions of all the fundamental principles of each edit, this book removes the mystery of digital wizardry.

**Tim Daly**
tim@photocollege.co.uk

▲ **above:** Print onto watercolor paper, page 96

▲ **above:** Create delicate tonal effects, page 66

CHAPTER ONE

# GETTING STARTED

# Digital workstation

You don't have to break the bank to buy a good-quality workstation, but it is essential to equip yourself with the correct gear.

## Computers

**The Apple G4 computer system is a well-established favorite with imaging professionals due to its ability to run applications like Adobe Photoshop at much faster speeds than competitors.**

Today's computers are lightning-fast. Digital photography involves lots of data and creates enormous documents compared to humble office word processing. Big image files need computers with a fast processor to speed through the edits so that you are not left clock-watching. With the quality and resolution of digital cameras on the incline, ensure your machine is future-proof, and will allow upgrade and customization.

There are two dominant computer platforms: the Apple Macintosh and the Windows PC (personal computer). Both systems are designed to link with all popular software and hardware components, and there is no noticeable difference in the end result. The choice of a system should be based on personal preference and circumstances. Macs are favored by design and publishing professionals, whereas PC-running Microsoft Windows can be found in offices worldwide.

**A top-of-the-range PC, like this Silicon Graphics workstation, will provide ample processing speed and clever internal components to rip through the most lengthy filtering command.**

# Memory

After the processor, the most influential part of your PC is memory. Random Access Memory (RAM) is the part of your computer which stores all unsaved data and open applications during work in progress. During a complex set of commands, data is held in the fast-responding RAM to allow you to operate your PC at top speed.

If not enough RAM is installed, overflow data is stored on the hard drive, a component with much slower read-and-write speed, which slows the process right down. When a computer crashes, all unsaved data held in the RAM is lost, with potentially catastrophic results. For image editing, it's important to install five times as much memory as the largest document you are ever likely to work on, with 256Mb being a good starting point.

# Software

At the heart of the PC is the operating system, sometimes referred to as the system software. Apple's OS X and Windows 2000 are examples of operating system software, designed to allow the physical hardware components and software applications to talk to each other. With each development in digital technology, newer products are designed to only work with the most recent operating systems, and may not be compatible with computers running older software.

# Monitors

Like a good camera lens, the computer monitor is a vital part of your PC. If your budget is limited, opt to buy a top-quality monitor at the expense of a PC with the fastest processor, rather than the other way around. Many digital professionals still prefer to use the cathode ray tube (CRT) monitors in favor of the more recent thin-film transistor (TFT) models. In this respect, size is important, with a 19-inch monitor giving you plenty of room to view high-resolution images alongside the computer desktop clutter of your software application.

**A professional, hooded CRT monitor such as the LaCie offers a better environment for accurate colorwork.**

**An all-in-one computer like the Apple iMac offers space efficiency without compromizing speed or convenience.**

# Digital cameras

With cameras to suit even the smallest of budgets, shooting digital photographs has never been easier.

**Good-quality cameras have all-important mode dials and switches within easy reach.**

## Digital compact

Just like a film-based compact, the digital compact is a versatile tool for creative photographers keen not to miss out on the action. Fitted with a charge-coupled device (CCD) image sensor able to produce between two and four million pixels, excellent print quality can be achieved up to foolscap (A4) size without over-enlarging.

Better cameras are fitted with a non-interchangeable zoom lens, capable of shooting in a semi-wide-angle mode to a long telephoto. Great for shooting all manner of subjects, such as travel, people, and landscape subjects, this kind of camera will usually have limited manual settings for precise control over shutter speed and aperture values.

## Compact

Designed to present the keen photographer with more advanced controls and functions, the top-price compact can capture four to six million pixels. With a better build quality, better onboard software, and the opportunity to use clip-on lens attachments, this kind of camera will afford more creative play than budget models. With an interface for attaching external flash units, and high-capacity memory cards, better digital compacts often use innovative viewing systems, such as a rotating LCD preview screen or a through-the-lens finder for more accurate composition.

**With a more versatile zoom lens and direct, through-the-lens composing, this kind of compact camera offers more control.**

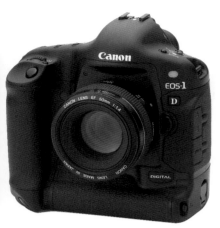

## Browser software

All digital cameras are supplied with browser software, so you can choose which images to transfer to your PC. Appearing just like an index print or contact strip on your desktop, the browser can also present you with technical information such as shutter speeds, aperture, and ISO used on each shot.

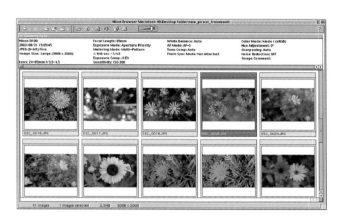

**Rugged, and built to withstand repeated use outdoors, the digital SLR is the most sophisticated camera available.**

## Digital SLR

The single lens reflex (SLR) camera's main advantage is its ability to use interchangeable lenses, and operate under fully manual conditions. Based on the Nikon or Canon professional camera ranges, digital SLRs can use the same lenses from a conventional camera kit, albeit with a slight reduction in focal length. With an image sensor able to produce six to 16 million pixels, image quality will be pin-sharp and good enough for commercial, printed reproduction.

## Memory card types

### SmartMedia
Smaller and thinner than others, the SmartMedia card has a clipped corner and a gold contact for linking to the camera. Made in varying capacities, up to 256Mb, there are several different voltage variations, which are not compatible with all camera types.

### CompactFlash
Chunkier than the SmartMedia card is the square-shaped CompactFlash memory card. With 50 tiny female plugs, the cards dock easily into the camera card bay. Bigger capacities are available, up to 1Gb, and cards are available with different read/write speeds for top performance.

### IBM Microdrive
The largest capacity cards are the IBM Microdrives, sold in 340Mb or 1Gb sizes. The Microdrive is in fact a mini hard drive, and has the same 50-pin connector of a CompactFlash card. Not all cameras using CompactFlash can support the Microdrive, but many can use both.

### Memory Stick
Used by a wide range of Sony digital devices, the Memory Stick has a unique shape compared to other products. Special Memory Stick card readers are needed to transfer images to your PC if you cannot make a direct camera-to-computer connection.

**Dual-format card reader**
A useful addition to your kit is the multi-purpose, dual-format card reader. Able to accept SmartMedia, CompactFlash and IBM Microdrive media, these devices can remain plugged into your computer for repeated use. Most are powered from your PC's USB port, so there's no need for additional power leads, and no drain on your camera's batteries during download.

# Inkjet printers

Great advances in printer technology mean that desktop inkjets can equal the quality of conventional photographic prints. At a cost within the budget of any serious photographer, there's never been a better time to start.

**The six-color inkjet used with glossy paper can produce prints indistinguishable from a real photograph. This printer can also accommodate paper on a roll for printing panoramic images.**

**At close quarters, each individual dot can be clearly seen, but these merge together when viewed from a distance.**

## Ink color

Inkjets mimic the appearance of continuous-tone photography by a simple optical illusion. Tiny droplets of cyan, magenta, yellow, and black (CMYK) ink are not mixed together, but placed side by side on the paper. When viewed from a distance, these colors merge together and, like watching a television screen, your eyes are unable to discern individual dots. The quality of an inkjet printer is determined by how many colors it can print with, and how small each ink dot can be made. There are three common printer types: the home inkjet, the photo-quality inkjet, and the professional inkjet.

## Home inkjet

Aimed at the home office or small-business user, the most economic kind of desktop inkjet printer prints with CMYK. The achievable print quality is acceptable for text, charts, and simple business diagrams, but lacks the ability to reproduce the subtle colors found in a photographic image. The most obvious sign of low-quality output are tell-tale dots of ink evident in flesh tones.

**Cheap and fast to print, this kind of desktop inkjet will not bring out the best of your digital image files.**

## Photo-quality

A much better kind of inkjet is the photo-realistic printer. It is equipped with more sophisticated driver software, and can print onto a much broader range of media. With the addition of light cyan and light magenta, the unique colors of human skin tone can be reproduced, perfect for the keen photographer. Ideal for printing archival images, and sold at a higher cost, look out for a device which prints with light-fast inks, such as the Epson Stylus Photo range, using "Intellidge" ink cartridges. It's important to use the recommended papers for excellent-quality output.

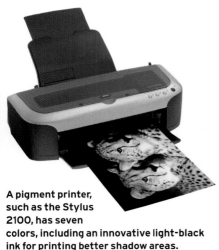

A pigment printer, such as the Stylus 2100, has seven colors, including an innovative light-black ink for printing better shadow areas.

## Card-slot printers

Many inkjets are fitted with a digital camera memory card-slot, so you can make prints without the need for a computer. Card-slot printers offer the convenience of fast, direct printing for circumstances when quick proofs need to be on location. A limited range of printer software routines are available when printing in this way, such as Auto Contrast correction and Auto Sharpening.

The USB-powered printer is the perfect way to make prints directly from your digital camera.

## Professional

Sold at four times the cost of a photo-quality inkjet, the professional printer is built to cope with the rigors of the commercial photography world. Spraying ink at the finest possible particles and resolutions, these devices aim to produce prints which are indistinguishable from conventional photographic prints. Based on pigment ink colors rather than the less stable, dye-based ink, prints are guaranteed to last at least as long as conventional color photographic media. With better-quality ink, the consumable costs are much higher, but most recent printers offer individual ink color cartridges.

The card-slot printer is a versatile tool for using away from a permanent imaging workstation, ideal for making quick prints out on location.

## Portable

For those photographers who want to carry a portable printing device, there are several miniature dye-sublimation devices on the market. Using a thermal-bonding technology, these kinds of output devices fuse color onto special paper for a high-gloss finish. Despite the higher cost of consumables, portable dye subs can be plugged directly into the camera for fast print-making.

The choice of media type and print quality will determine how well your print is produced, regardless of the resolution of your image file.

**Printer software**
Despite sophisticated image-editing software, print quality can be profoundly affected by the smaller but none-the-less important printer software. Devised to ensure that the printer matches the specific ink needs of different media, printer software needs to be driven properly for best-quality results. The software controls color balance, contrast, and output quality, so you can manually adjust the kind of imbalance often caused by third-party paper media.

# Scanning film and prints

If you're planning to retouch and restore old photographs, it's essential to invest in top-quality scanning equipment.

## Scanner facts

**A flatbed scanner is an inexpensive addition to your workstation and offers the chance to manipulate existing photographic prints.**

Scanners are small, desktop devices which plug into the USB, SCSI, or Firewire socket. Inside the scanner is an array of light-sensitive cells designed to convert your print or film into pixels. Unlike the fixed position, rectangular-shaped sensors found in a digital camera, scanner sensors are typically arranged in a thin strip, and track the original during scanning. The quality and price of a scanner is determined by how many pixels it can create per linear inch of original, a term referred to as "resolution".

High-resolution scanners can produce files for large print-out even from small originals. Lower-resolution devices do not offer such enlargement, but are fine for most printing. Scanners can be operated via your image-editing package, or through standalone software applications.

## Flatbed scanners

Essential to any workstation is the flatbed scanner. Like a photocopier, the flatbed is used for scanning prints, drawings, and flat artwork. Good scans only come from good-quality original artwork, but improvement can be made by a sensitive operation of the special scanning software. Flatbeds can also be used for capturing shallow three-dimensional objects, and for collecting images for still-life montage projects.

## Film scanners

The purpose-made film scanner has a sensor designed to scan at very high resolution due to the tiny size of the originals. Divided into two types—the 35mm scanner and the medium-format scanner—both are able to scan negative and positive film.

Successful film scanning is all to do with careful cleaning of the film before the scan, and minimizing contrast gain. Many better devices have an additional software toolbox, such as Digital Image Correction and Enhancement (Digital ICE). This set offers extra controls for restoring faded color and contrast, plus a filter for reducing film grain.

# Multi-purpose

A recent innovation is the multipurpose film and flatbed scanner. Like a flatbed, but with an additional light source in the lid, this kind of peripheral can be used for capturing data from a wide range of film formats, and shapes. Best results are achieved when scanning larger-format materials at the highest possible resolution, then down-sampling the document to a smaller dimension.

Scans from small-format film such as 35mm will not compare favorably to scans made with a dedicated film scanner. Better models are the mid-price devices, made by Microtek and Umax.

**A top-quality combination scanner can cope with a wide range of transparent and opaque originals, and is an ideal device for a small graphics studio or keen photographer.**

## PC tips

To improve the speed of data transfer between your scanner and PC, it's essential to install as much RAM as your budget will allow.

# Software

All scanners are packaged with basic scanning software, so you can determine how many pixels you want to capture. All have simple controls for capturing in grayscale or RGB color mode, an enlarge or reduce function, and the capture resolution scale. Limited-contrast and color controls are offered with budget scanners, and this is best tackled post-scan in your image-editing package. Better scanners can be operated through advanced scanning software, such as the Silverfast application. With precise tools for on-the-fly correction and color calibration, Silverfast will enable you to use your scanner at top-quality, at all times.

**The Canoscan film scanner works with both 35mm and APS film formats, and can produce enough data for a top-quality large-scale print.**

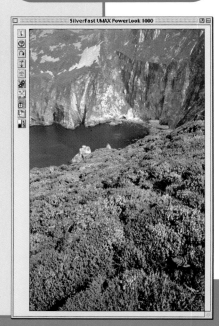

**Silverfast scanning software offers an advanced set of software tools for extracting top-quality scans for professional reproduction.**

# Scanning monochrome

**Black-and-white originals are easy to scan properly, providing you follow a few fundamental principles.**

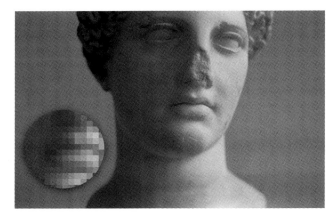

The grayscale image is created by pixels set within a 0–255 brightness range, where black is 0 and white is 255.

## Grayscale mode

A standard black-and-white image is described as Grayscale mode in digital imaging and is constructed from a palette of 256 different tones, from black to white. With this 8-bit palette, that holds many subtle shades of gray, it is impossible for the human eye to detect any banding or posterized areas. The single-scale grayscale image needs only one-third of the data of an RGB image, and is therefore leaner, and easier to transport, takes up less storage space, and is faster to edit. All of Photoshop's color controls are unavailable when working on a grayscale image, but if converted to RGB color mode first, these will become another option.

## Scanning basics

Good grayscale scanning involves the careful setting of white and black points either at the scanning software stage or later in your image-editing program. The golden rule of scanning is to minimize any gain in contrast and if at all possible, make your scan slightly lower than the original. This permits both low- and high-contrast printing at a later stage. Four different tools can exercise contrast control: the simple Contrast and Brightness sliders; the more advanced Levels dialog; the Dropper tools; and the Curves controls.

A standard scanning control panel set to capture in the Grayscale mode. Although contrast correction can be applied using the simple sliding scales found at the bottom of the panel, better quality adjustments are made using Levels controls.

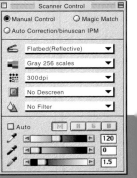

# Enhanced mode

Many advanced scanning programs permit an enhanced 12-, 14- or 16-bit grayscale mode, so you can capture the delicate tones of professional photographic prints. Although drawn from a much bigger palette, super-sampled grayscales need to be squashed back into the normal 8-bit mode for creative editing and later print out. Despite very little visual difference when comparing 8-bit scans to an enhanced scan, higher-quality grayscales are preferable if you intend to apply delicate gradients across the image.

**The Dropper tools can be used to set the highlight and shadow points in your original. If applied at the scanning phase, it is vital to ensure that you're working on a high-resolution preview, so you can point at the location of your extremes. Droppers can also be found in the Levels dialog in your image-editing program.**

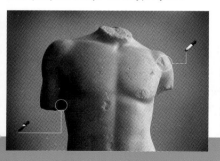

**Toned photographic prints are best captured in the RGB color mode.**

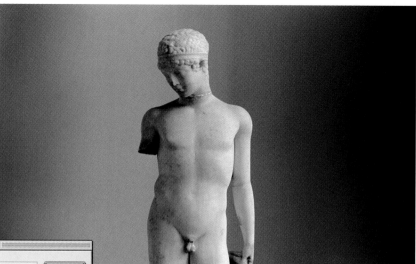

**All the brightness data for a grayscale image is held within a single channel, as described in this Levels dialog.**

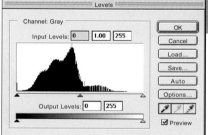

## Tones and tints

Many monochrome originals are in fact colored, such as a sepia-toned family photograph. In such instances the innate qualities of the original would be lost if captured as a grayscale scan. A much better way to scan this kind of original is to use the standard RGB color mode, which will preserve both the colors and tonal range of your original.

**The Grayscale Channels palette**

## Scanning film

Always scan film originals at the highest possible resolution, and save and store this master file, just like a negative. Once opened, you can resize, edit, and size without damaging your file, and interpret the image just like a master darkroom craftsman.

# Scanning color

Keeping colors true and free from the by-products of poor color management is the key to quality scanning.

## Image make-up

Unlike a single channel grayscale image, the color image is formed from three 0–255 scales: red, blue, and green. With 16.7 million color combinations possible, even the most subtle shades and colors of the natural world can be captured within this palette. With a color image, four separate channels are created: the RGB or master channel, plus one each for red, green, and blue. In the Levels dialog box, each of these channels can be edited independently, although most brightness corrections are applied to the RGB-composite channel only.

**Left: As each image differs in the quantity and distribution of pixel color, so the histogram shapes found in each individual channel will vary too.**

**Right: A well-exposed 6x4.5 inch format color transparency.**

**Left: A correctly exposed 35mm color negative frame.**

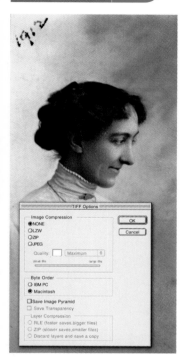

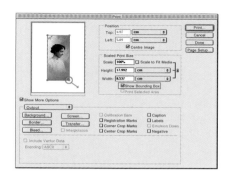

# Sharpen with USM

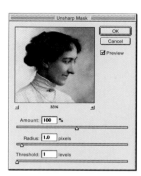

**01** All scanned images look better after a bit of software sharpening, especially if they've been enlarged. With very small originals, try the Unsharp Mask filter (Filter>Sharpen>Unsharp Mask) with these settings: Amount 100; Radius 3; Threshold 1. Immediately after filtering, compare the results of the USM with the unsharpened original by pressing Command/Ctrl Z to turn the filter off, then again to turn it on again. If the filter looks too severe, turn it off and apply a smaller Amount of 50.

**05** To confirm your image is the size you want it to be, use the File>Print With Preview command. This dialog box shows your image file positioned on the currently chosen paper size. If too big or small, simply make sure the Show Bounding Box option is selected, then drag a corner of the image to achieve your new size.

**04** Scan your original and immediately save the image file in the Tiff format, as an uncompressed option. This format will keep your image in tip-top condition and prevent it from losing quality. Tiffs are cross-platform and are accepted by virtually all image-editing packages.

### Resolution

There's not much point in scanning photographic prints any higher than 300 pixels per inch (ppi), because there's not that much lurking detail there in the first place. It's much better to set your scanning resolution to match the resolution of your intended output device, such as 200ppi for an inkjet printer.

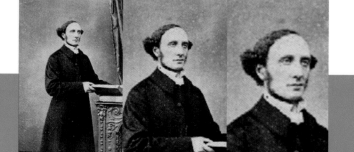

**Navigator**

# Scanning big originals

Sometimes, your flatbed scanner just isn't big enough to cope with larger photographic prints, but stitching two scans together is much easier than you think.

manipulate it

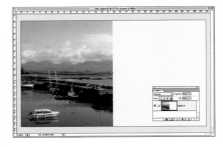

### scan it

**01** Place your oversized print on the scanner, making sure you've included at least one complete side and three edges. Drag your Marquee tool around the preview image until you've included as much of the image as possible. If your print isn't straight, reposition it and do another preview. Scan and save this left-hand section.

**02** Reposition the print to include the opposite side, but don't be tempted to guess where the exact join should be between this and the previous scan. Allow a generous overlap between the two halves of the print, and scan and save using exactly the same settings as before.

**03** Open up the left-hand image and double click on the Background Layer icon. When prompted, rename it to "Layer 0". Next, do Image>Canvas Size and increase the width to twice its current value (or three times if you have three sections to your project). Select the Move tool and drag your layer to the left-hand edge of the new canvas.

---

**Technical details**
Umax Astras scanner
VistaScan software
Adobe Photoshop 7

 **Photoshop tools**
Eraser
Levels
Color Balance

**Photoshop keyboard shortcuts**
Move tool          V
Levels             Ctrl + L

**04** Next, open up your right-hand image and do Select>All, then Edit>Copy. Close this image window and click into the left-hand image. Do Edit>Paste and watch how the two halves are now united in the same document. Use the Move tool to drag the right-hand section into place until perfectly overlapped.

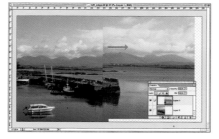

**05** It's very likely that one of the layers will be a different color and level of contrast compared to the other, so only attempt to adjust the one layer which looks the most out of sorts. Do Image>Adjustments>Levels and move the Midtone slider until this layer matches the other. Only make slight adjustments at this stage.

**06** Still on the same layer, use the Color Balance dialog to correct any inconsistencies between the two layers. Apply the adjustments to the midtone areas only and be very sparing in your application. Remember, the task is to match the two layers, not to fully correct the image.

**07** Finally, select the Eraser tool and choose a large, soft-edged brush. Click and hold the Shift key to constrain the tool into a straight line. Next, drag the Eraser over the boundary edge of the uppermost layer, until the sharp edge is removed, and all traces of the join disappear.

**08** The final stage is to do Layer>Flatten Image and then use the Cropping tool to remove any excess canvas. Apply the normal contrast and color corrections using Levels and Color Balance controls until your image is ready to print.

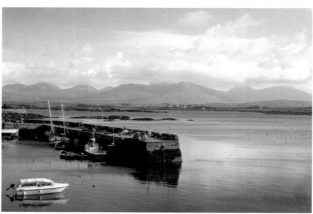

**Matching up the two halves**
Zoom in on your image to at least 200 percent so you can see exactly where the join should be made. Try and line up the two halves by overlapping a small shape or detail. If the join works at the base of the image, but not at the top, then you'll need to rotate one half until it's lying in the same direction.

 **Keep in mind**
It's essential to match the two halves before even thinking about correcting your scans.

 **Navigator**
Color balance        p94
Borders and edges  p100

# Fixing low-contrast

Flat and lifeless images can easily be fixed, whether they've been captured by a digital camera or a flatbed scanner.

## Digital images

 manipulate it

**01** This image was shot in murky natural light without the use of a flash. When the image histogram is examined, it displays most pixels set between the midtone and shadow areas but very few in the highlight end. Digital cameras often create low-contrast results to minimize the amount of data.

**The Histogram is found under Image>Histogram, and presents a clear read out of the brightness of all the pixels in your image. The horizontal scale describes pixel brightness from black to white, and the vertical columns describe the actual number of pixels of each tone.**

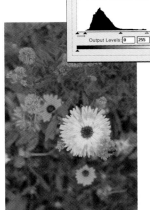

**02** Do Image>Adjustments>Levels and examine the Levels dialog, as shown. Move the highlight triangle to the left until it hits the base of the black mountain shape. Next, move the shadow triangle until it too sits at the base of the central mountain shape. Both commands will restore contrast without causing adverse posterization.

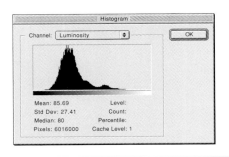

**03** The corrected image has much more punch and vitality. A normal-contrast image should always have a small amount of full black and pure white and a good range of tones in between.

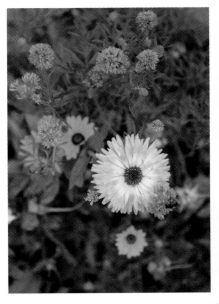

Histogram

Channel: Luminosity OK

Mean: 85.69      Level:
Std Dev: 27.41   Count:
Median: 80       Percentile:
Pixels: 6016000  Cache Level: 1

**Keyboard tips**
In any Photoshop dialog box, by pressing the Alt key, you can change the Cancel button into Reset. Clicking on the Reset button means you can cancel your current edit without closing the dialog box.

**Navigator**
Fixing blurred photos     p44
Creating emphasis          p80

# Scanned images

manipulate it

**01** This vintage print was low-contrast to start with and needs to be corrected "on the fly" (another term for processing by scanning software during the scan itself). Crop the Marquee tightly around your original, and make a preview scan to determine the exposure. Turn off any Auto Contrast correction and set your scanner to capture at 300dpi.

**02** Open the Levels dialog box in your scanning software, and drag both shadow and highlight sliders to the new position, as shown. This will perform a tonal correction during the scanning process. If you are working on a color image, make sure you are correcting the RGB composite channel rather than individual color channels, or your image will have a huge color imbalance.

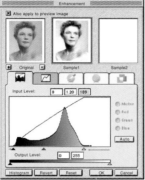

**03** The result will be corrected without the need for processing in Photoshop, and will have an even distribution of tones, which will not be posterized by future manipulation or enhancement.

**Excessive correction**
Too much Levels adjustment will leave your image histogram with giant vertical gaps and cause colors to be posterized. This will prevent any future sensitive adjustments and creative edits. If you are faced with very bad-quality originals, don't plan any extensive editing.

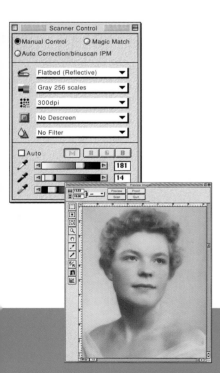

## Scanning textured prints

Luster or stippled surface photographic prints will appear unsharp and even granular after scanning. Use the Filter>

Noise>Median Filter to reduce the appearance of a textured surface. Only apply a tiny edit such as 1 or 2 pixels to improve the surface.

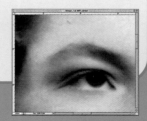

# Fixing high-contrast

**Contrasty images are full of strong whites and deep blacks and make the tricky task of printing out harder than normal.**

**manipulate it**

## Monochrome

**scan it**

**01** Contrasty monochrome images are difficult to print properly on an inkjet, so must have their deep blacks and bright whites reduced before output. With an old monochrome print, it's much easier to leave the tonal adjustments to do in Photoshop using the Curves controls.

**02** The Grayscale Curves control is an easy, yet flexible way to push and pull pixel brightness in up to 15 different tonal sectors. To minimize the effects of excessive contrast, first make sure that the shadow point is set to the bottom right of the grid, as shown. Next, move both white, black, and midtone points until your image loses its extremes.

**03** The resulting image has now regained darker highlights and slightly lighter shadows, and will be much less troublesome to print. You can experiment with overall image brightness by pushing or pulling the the central midtone point around.

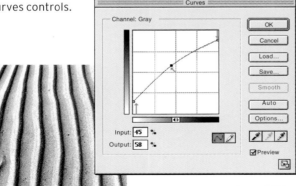

**Navigator**

Test printing    p92
Vintage printing    p98

# Color

scan it

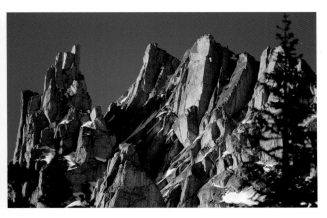

manipulate it

**02** Do an Image>Adjustments> Levels command and drag the dialog to a position on your desktop where the image remains in full view. In the Output Levels section, found at the base of the dialog, gradually pull in to the center both the highlight and the shadow triangular sliders. This has the effect of knocking out both pure white and black. If your image now looks muddy, adjust this by moving the midtone triangle to the left in the Input Levels.

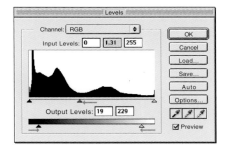

**03** The final image does lack the punch and contrast of the raw scan, but will be much easier to print. In fact, when output to a standard inkjet printer, it will show a slight gain in contrast.

**01** A typical scan from a color transparency shot under sunny conditions. With deep-black shadows and pale highlights, a normal Levels command to lighten the image would run the risk of bleaching out the highlights.

### Using the Info palette
You can measure the highlight and shadow areas of your image by using the Dropper tool in the desktop Info palette. Found under Window>Info, click on the Dropper in the top left quadrant and set to Grayscale. This presents a simple 0 percent or white-out to 100 percent black read-out whenever you place your cursor over a potentially dangerous area.

CHAPTER TWO

# REPAIR

# Removing dust and scratches

Scans made from print and film originals will show every single speck of dust, but these can easily be removed by using one of two simple Photoshop techniques.

## The Clone Stamp

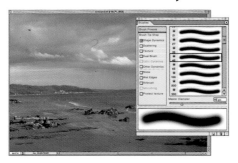

manipulate it

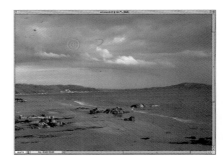

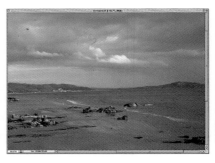

**01** Pick the Clone Stamp tool from the toolbox and make sure it's set to 100 percent Opacity, Normal color mode and Aligned in the Options bar. Next, click on the Brushes palette and select a soft-edged brush. Hard-edged brushes are better to use as they create less softening of your image, but soft-edged brushes are easier to use if you're a beginner.

**02** Zoom in to the image and choose an area that you'd like to remove. Next, carefully select a nearby part of your image that you'd like to replace it with. With gradients and delicate color, similar areas may be very small. Once identified, move your cursor over the spot, click, and hold the Alt Key, then click once with your mouse. This command samples your chosen area.

**03** Move your cursor away from the sample area and over the scratch you'd like to remove. Click and hold your mouse, and paint away the offending area. As you paint, keep close watch on the sample area, which is identified by a cross, as this will remain the same distance from your brush and could drift into an unwanted area. To do a good job, you need to watch both cross and brush at the same time.

**Further info**
History states can be extended from the default 20 to a maximum of 100 by changing the Preferences dialog box.

**Keyboard shortcuts**
Zoom in            +
Zoom out           -

# The History brush

manipulate it

**01** For more severe cases, frequently found when scanning old film or prints, the History brush will give much better results. First, apply a Gaussian Blur filter to your entire image to blend random color pixels into surrounding colors. Increase the blur gradually in single pixel increments until the blemishes disappear. For this dusty image, an 11-pixel blur was applied.

**02** Don't worry that your entire image will have softened at this stage. In your History palette, make a Snapshot from this Gaussian blur state and then immediately reverse back and choose the previous state. Your image will now regain its full sharpness. Pick the History brush tool and choose a 10-pixel brush. Click the History brush in the Snapshot until the tiny brush icon appears alongside (shown inside the red circle).

**03** Zoom in close to your image, gently apply the History brush to the marks, and watch it rub back to the blur snapshot until the blemish completely disappears. To maintain maximum image quality and sharpness, avoid removing unaffected areas close by. The result is a clean, sharp image with some tiny areas of blur, which are too small to be seen.

## History

The History brush will not work with previous states or snapshots if you've changed image size, resampled resolution or mode between snapshots, and will appear as a No Entry icon on your desktop.

## Cleaning

Dust and foreign bodies can easily appear on your scans if you don't keep your scanner in tip-top condition. Wipe your flatbed scanner regularly with an anti-static cloth to remove foreign bodies and, if the glass becomes marked, remove with alcohol-free spectacle wipes. For film scanners, ensure that film holders are stored in a dust-free environment.

**Navigator**
Removing blemishes    p32
Removing tramlines    p40

# Removing blemishes

Historic photographs are easily damaged by environmental conditions but can be easily coaxed back into existence using some clever filtering.

**scan it**

**01** This image is a typical example of an albumen print that has become mottled due to storage in damp conditions. The print exhibits an all-over pattern of moisture marks, which would be impossible and too time-consuming to remove with the Clone Stamp tool. This technique uses filters, sacrificing image sharpness for a smoother appearance.

**manipulate it**

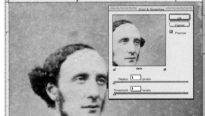

**02** Work on the area that is most important first: in this case, it's vital to retain as much of the sharp facial features as possible. From the Filters menu, choose the Dust and Scratches filter. Adjust the Radius until the tiny marks disappear from the face without blurring it.

**03** Follow this with the Median filter. Concentrate on the clothing items and move the Radius slider until the textures start to blur. Don't worry about the loss of sharpness elsewhere at this stage.

**04** Pick the History brush from your toolbox and open your History palette. Click on the previous state—in this case, the Dust and Scratches command—and then nominate the Median filter as the History brush target. This will make your image reverse one step and allow you to introduce the softening Median filter at the end of your History brush.

---

**Technical details**
Umax Powerlook
1000 flatbed scanner
Adobe Photoshop 7

**Photoshop Tools**
History brush
Gaussian Blur filter
Median filter
Dust and Scratches filter

**Keep in mind**
History states can be saved as snapshots, by clicking the tiny Snapshot icon found at the base of the History palette. Snapshots are stored at the top of the palette and are not deleted like normal states.

**05** Drag the History brush in the clothing areas of your image, until you can see the light blotches become less noticeable. They won't fully disappear, but they will become much less visible. A more drastic filtering would reduce the sharpness of the image beyond acceptable limits.

**Filter power**
Blurring and noise-reduction filters can be very strong, even at low levels. If you are unfamiliar with the quantities needed, set the Radius value to 1 pixel and increase in 0.5 increments until it looks right. Remember, too much will cause your original to lose it's all-important texture.

**06** The final stage is to repeat steps 02 and 03, but this time using the Gaussian Blur filter. Concentrate on the background for this stage, as it can take a greater amount of blurring than the previous two areas. Select your History brush and "paint" away the mottled background areas until the image looks clean.

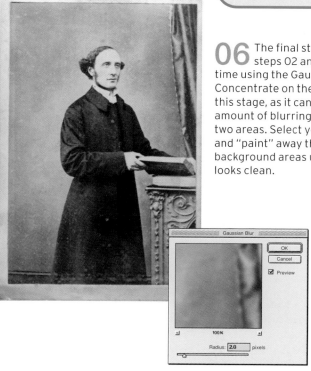

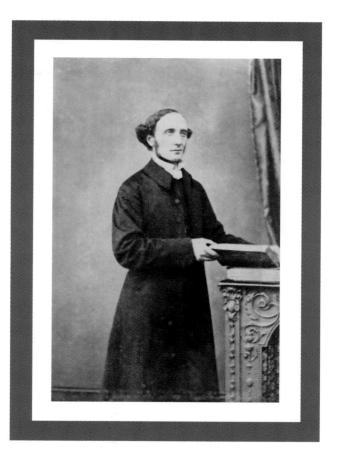

**07** The end result shows a compromise between a loss of sharpness and a reduction in the overall blemishes. Because the damage was so widespread, the tactic was to apply a softer filter to the most important areas, such as the face, followed by more severe blurring, using the Gaussian Blur filter, on the background.

**Photoshop keyboard shortcuts**
To increase the Filter value
in small increments          **Arrow Up**

**Navigator**
Borders and edges          p100
Vintage printing            p98

Repair 033

# Removing cracks and folds

Even folded photographic prints can be rescued and restored to their former glory using Photoshop's Quick Mask mode.

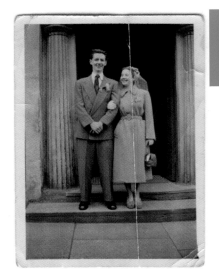

manipulate it

**02** In your toolbox, select the Quick Mask mode and paint in one side of the folded print. Take care at the edges of the mask, and change the brush to a smaller size if needed. Use a hard-edged brush, so the resulting selection will have a sharp edge. Work your way around all edges, then use the Bucket Fill tool to fill in the center.

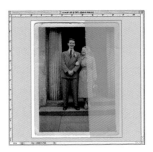

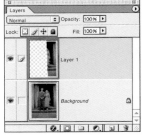

**scan it**

**01** A tiny and precious print was discovered folded in two halves, and when re-opened, the photographic emulsion had cracked off in the fold. An entire strip of the print was missing, but it can easily be put back again. When scanning very small originals, choose a high-resolution capture setting such as 600ppi.

**03** When the mask is complete, click back into normal editing mode, and watch the selection outline appear. Follow this immediately with an Edit>Copy, Edit>Paste command, which will create a new layer out of your carefully selected Quick Mask area. Make sure your Layers palette looks like this.

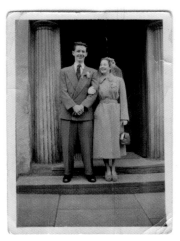

**04** Make the new layer active and select the Move tool from your toolbox. Next, place your finger above the Arrow Left key on your keyboard. Each time you press the key down, the entire layer will shift to the left, one pixel at a time. Keep on pressing the Arrow left until the two halves come together and the white crack completely vanishes.

---

**Technical details**
Umax Powerlook 1000 flatbed scanner
Umax Magicscan 7
Adobe Photoshop 7

**Photoshop tools**
Quick Mask
Clone Stamp
Nudge

**Keep in mind**
Avoid, where possible, the use of soft-edged brushes when working in Quick Mask mode, as they will produce a feathered edge to your selection.

**05** Next, work on any minor folds and damage by using your Clone Stamp tool. The placement of the sample point is the most crucial aspect of using this tool. Look for similar textured areas to sample from, as shown in this example. Always keep an eye on the position of the sample cross as you paint.

**06** Work around the perimeter edge of the image and remove all folds and cracks that are visible at 200 percent enlargement. When you are satisfied that you have completed this task, use the Crop tool to remove any non-essential borders or ripped edges from your project.

**07** Next, improve the brightness by using the Levels controls. Create a white point by sliding the white triangle to the left, and brighten the image overall by sliding the midtone triangle to the left, as shown. This command will revive any dull and uninspiring print.

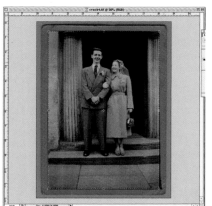

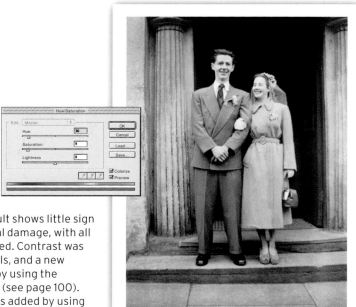

### Copying to another layer

This technique is much better than trying to join the crack by using the Clone Stamp tool, as it avoids the use of a painting sequence. Even with a steady hand and careful brush control, the Clone Stamp tool will always remain noticeable when compared to two halves that have been simply squeezed together.

**08** The final result shows little sign of the original damage, with all physical folds removed. Contrast was improved using Levels, and a new border was created by using the Canvas Size controls (see page 100). A final warm tone was added by using the Colorize command in the Hue/Saturation slider.

**Photoshop keyboard shortcuts**
Nudge a selection or layer
in one-pixel increments     **Arrow up, down, left, or right**

**Navigator**

# Removing stains and marks

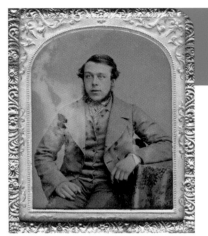

**Even the most fragile photographic processes can be rescued and improved by careful scanning and editing.**

**02** Once removed from its protective case, the rear of the glass plate shows a total breakdown of the black backing paint, which is the sole cause of the mottled and stained appearance of the actual image. Use a sharp scalpel blade and carefully remove the cracked black paint from the rear of the plate. The image will remain unaffected, as the emulsion coating is on the other side.

**03** With such a small original, it's important to scan at a higher resolution than normal. Set your scanner to capture at 600ppi, and use flatbed or reflective mode rather than transparency, even though the original is see-through.

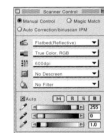

**01** This delicate, hand-colored vintage photograph is a collodion positive, from the 1850s. The actual image is a glass negative backed with black paint to give the impression of a positive, encased in a decorative mount and backing board. Many of these delicate images deteriorate due to poorly applied backing, resulting in staining. It's much better to re-scan the glass negative after it's been removed from its mount.

**04** Place your glass negative face down on your scanner, removing all dust and paint beforehand with a blower brush. Before closing the scanner lid, drape a sheet of black paper over the top of the negative. This will help to create a much better-quality scan.

---

**Technical details**
Umax Powerlook 1000 flatbed scanner
Umax Magicscan 7
Adobe Photoshop 7

 **Photoshop tools**
Pen
Clone Stamp

**Keep in mind**
Like selections, paths can be saved with your image file but occupy much less storage space. Paths are created from vector outlines rather than pixel-based layers and channels, so create little extra data.

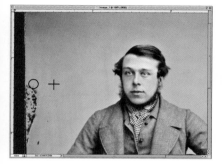

**05** After the scan, drag a rectangular Marquee around the image to create a clean, straight edge. Next, use your Clone Stamp tool to paint away any damaged areas. Position your sample point in an undamaged area, then use this to stamp over the damage. Most of the original marks caused by the black backing have disappeared.

**Using the Pen tool**

The hardest of all tools to get a grip on, the Pen tool offers the most precise way of making a selection. If you are unfamiliar with the way it operates, keep your History palette on the desktop, so you can see and repeat what you've done after each command.

**06** The final retouched image looks remarkably high quality, and retains all of its original sharpness and clarity. At this point, it's finished and ready to print, but you can further enhance it by putting it back into its original decorative casing.

**07** Return to the original scan with the decorative border, and use the Pen tool to create a careful Path around the inner aperture. Use the Pen to create Bezier handles, so you can push and pull them into creating an exact arc at the top of the mount. Once complete, save the Path and turn it into a selection.

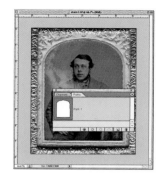

**08** Return to your retouched plate and do Select>All, then Edit>Copy. Close this image window and then do Edit>Paste Into, to send your copy inside the selected shape. Use the Transform tools to adjust the size and position of the paste. The final result shows off the delicate beauty of the original with all signs of damage and ageing removed.

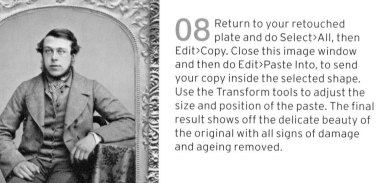

---

**Photoshop keyboard shortcuts**
Shift, Alt,
Ctrl/Command          changes current Pen tool

**Navigator**
Building up missing detail          p78
Scanning small originals          p20

# Restoring a faded photograph

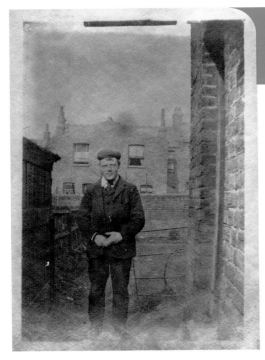

Old photographic prints do not age well, especially if they have been exposed to excessive light over the years. With some digital care and manipulation, they can be revived, however.

## scan it

**01** This very old print is like most family album heirlooms, printed on dull and uncoated photographic paper. Over time it has started to darken noticeably in the center, and partially reversed in the bottom margin. Poor photographic processing is the cause of most problems, but these can be made less noticeable using Photoshop's Curves controls.

## manipulate it

**02** After scanning, isolate the bottom quarter by making a rough selection, using the Lasso tool. Apply a Feather to the selection, so your edit blends in better with the surrounding areas. The purpose of the next edit is to reduce the white areas.

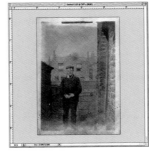

**03** Select the Burn tool from the toolbox, and set the tool parameters to work in the Highlights only, with an Exposure of 30 percent. These settings will enable you to darken down the area gradually, and make your edit much less noticeable. Apply the edit through a large, soft-edged brush to prevent streaking.

---

**Technical details**
Umax Astra flatbed scanner
Adobe Photoshop 7

 **Photoshop tools**
Curves
Burn

 **Keep in mind**
Small brush sizes combined with 100 percent Exposure settings result in streaky and obvious editing. If you do need to use this tool, keep it large, and apply it in several low-exposure stages, rather than in one full-on brushstroke.

**04** Once darkened down, the next step is to paint in any rough edges using the Clone Stamp tool. Try and remove any lighter areas by replacing them with color and texture, taken from the center of the image, as shown. Don't worry about neat and tidy edges at this stage, as the image will eventually be cropped.

**05** Remove any selections from your image, then do Image>Adjustments>Curves. Use your Curves controls to restore contrast to your image, and remove the dull and dark midtones. Push the Curves upwards to lighten the image in each of the midtone, and near highlight areas. Pull the near shadows downwards to reduce the amount of deep black. Try and mimic the shape of the curve shown.

### Using Curves
Curves have a habit of moving like rubber bands and creating unintentional effects. You can lock areas of the Curve that you don't want to move simply by clicking on it. Once locked, any future edit is restricted to a quarter of the line at the most.

**06** The image now has a touch more life and energy. Next, we need to improve the bottom quarter again, as this has lightened up during the previous Curves command. Make a selection using the Lasso tool, and feather it again, as in step 01.

**07** Open your Curves command to apply a new adjustment inside the selection area. Reduce the highlights by pulling the tip of the Curve over and downwards, as shown. Click pointers on other parts of the Curve, to stop the whole thing moving. Your highlights should now become darker.

 **print it**

**08** Edited to retain much of its characteristic color and texture, the final image is now ready for print. With off-white subjects, it's essential to try and print this kind of image on a matt or even cotton inkjet paper rather than a modern white, glossy surface.

**Photoshop keyboard short cuts**
To remove a locking
point from your curve    **Ctrl/Command**
    **+ click on point**

**Navigator**
Sharpening          p86
Scanning monochrome   p16

# Removing tramlines

Tramlines found on any film original used to be a catastrophic event that couldn't be cured by conventional photographic means. Yet with a patient application of the Clone Stamp tool, old prints can be given a new lease of life.

**shoot it**

**01** This black-and-white photographic print shows all the signs of tramlines, caused by minute specks of grit scratching the wet emulsion during processing. Ripping thin strips of the emulsion away results in thin black lines, which totally ruin the image.

**Constraining the Clone tool**
You can make the Clone Stamp tool run in a straight line, horizontally or vertically, by keeping the Shift key depressed while painting.

**scan it**

**02** When scanning, ensure that your digital file is low-contrast. With a low-contrast file, any apparent lines will be less evident, and much easier to remove with the Clone Stamp tool. Start by zooming in to 200 percent, so you can see the lines clearly.

**manipulate it**

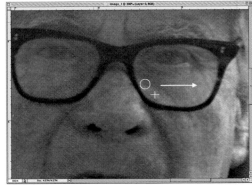

**03** Select a small, soft-edged brush. Place the sample point on the contours of the shape, so that, as you move the brush, the sample point picks up the right tone. This example shows where to place the sample and the brush. Keep changing the sample point as you encounter a different contour or gradient.

**Technical details**
Umax Powerlook
flatbed scanner
Adobe Photoshop 7

 **Photoshop tools**
Clone Stamp
Curves
Levels
Lasso Marquee

 **Keep in mind**
If you've got darker originals, you can easily reduce the density in the shadow areas by pulling the shadow points downwards, as shown in figure 07.

**04** As you paint away the thin black lines, pay attention to the changes of color and tone at the borders. As long as your sample point is placed correctly, border edges can be cloned, to replace damaged pixel areas.

**05** Follow the contours of the shape to find the sample point. Here, the left-to-right diagonal fold of fabric suggests where the sample and cloning points should be. This will work in a left or right horizontal stroke.

**06** After spending some time removing all traces of the tramlines, zoom out and check your progress. Look for areas that have been missed, and repeat the Clone Stamping until every trace of tramline has been removed.

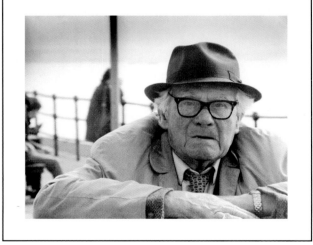

**07** Correct your deliberately flat scan by adjusting your image with your Curves controls. Do Image>Adjustments>Curves and create an "S" shape, as shown. With this adjustment, the midtones are made brighter, the shadows are made less widespead, and the highlights are increased slightly. The flat, gray print will now look much punchier.

**08** The final result is a gritty and realistic image, far from the damaged and dull original that we started with. The sky part of the image was darkened by making a Levels adjustment inside a feathered Lasso selection, and helps to create more emphasis on the face itself.

---

**Photoshop keyboard shortcuts**
Hide selection edges        Ctrl/Command + H

**Navigator**
Scanning high-contrast        p26
Scanning monochrome        p16

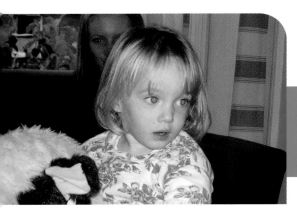

# Curing red eye

Even with modern digital cameras and sophisticated flashguns, red eye is still a problem for many photographers.

shoot it

**01** Caused by flashlight bouncing back off the retina and through a wide-open iris, red-eye can spoil a good portrait in an instant. This example shows a typical problem where poor light conditions have caused the child's iris to open wide.

manipulate it

**02** From your toolbox, choose the Sponge tool and pick the Brush tool properties palette. Zoom into the image and place your Sponge tool over the red-eye disc, and measure the current size of your brush. Use the Brushes palette to alter the Diameter, Angle, and Roundness so it matches the red disc exactly.

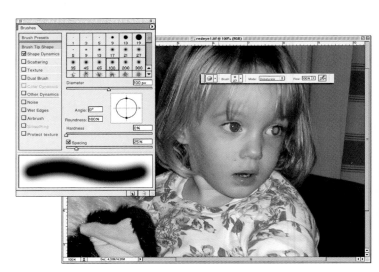

**03** Once your brush is perfectly shaped, change the Sponge tool properties until it's set to work in Desaturate mode with 100 percent Flow. Place it over the red eye and press down until the red disc disappears completely. In Desaturate mode, color will gradually drain away, leaving a monochrome patch in its place.

**Technical details**
Nikon 775 digital
compact camera
Adobe Photoshop 7

**Photoshop tools**
Brushes palette
Sponge
Burn

**Keep in mind**
If your red-eye problem is less severe than this example, you can paint color back into the eye by using the Paintbrush with Color Blending mode. Pick a color from the Swatches palette and replace the red eye with a new natural color.

**04** Repeat the process on the other eye and then change to the Burn tool. With both red discs removed, the eyes now lack a central dark area and can look just as false. The next process places a black iris back into each of the eyes. Set the tool to work on Midtones only and give it a 30 percent Exposure strength.

**05** Zoom close in to the eyes and use the Brushes palette to set your Burn tool at exactly the right size and shape. Aim to create a brush which paints a single disc inside the recently drained iris. The size should be near enough half the diameter of the brush used in step 03.

**06** Placed in the wrong position, clumsy eye edits can make your portrait sitter squint and look awkward. Rather than guessing the position, drag blue non-printing guides into position, so that the center of each eye is marked by the crossing of a horizontal and vertical guide.

**07** Now fully painted back in, the eyes look natural and without any traces of over-editing. Although many image-editing programs offer a special red-eye reduction tool, a similar process can be achieved using this method.

### Avoiding red-eye

If you get persistent red-eye problems when shooting with your digital compact camera, you can minimize the effect by changing the way you shoot. As light only travels in straight lines, try positioning yourself at an angle to your subject, then any returning flash light will not fire itself back into the lens.

**Photoshop keyboard shortcuts**
Reverse out of any edit          Ctrl/Command + Z

**Navigator**
Digital cameras          p10
Scanning film and prints          p14

# Fixing blurred photographs

Camera shake and slight errors in focusing can be made much less evident by the careful use of the Unsharp Mask filter.

### manipulate it

**02** Open your image and do a Filter>Sharpen>Unsharp Mask command. Although Photoshop is packaged with four sharpening filters, only the Unsharp Mask offers precise control in a demanding task. Zoom into your image and position the dialog box where you can see its effect on the window behind.

**03** The first stage in the process is to increase the Amount slider to 200. In normally focused images, the Amount is usually set within a 50–150 range, but with an example like this, a greater amount is needed. Notice how the image becomes slightly noisy after this command.

### shoot it

**01** Shot in a hurry, and without any time to set the camera up properly, this image is blurred due to camera shake. Caused by using a too-slow shutter speed, camera shake is usually fatal in conventional photography, and has ruined many a fine intention.

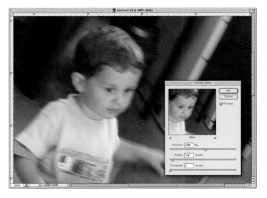

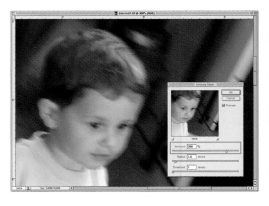

---

**Technical details**
Adobe Photoshop 7

 **Photoshop tools**
Unsharp Mask filter

 **Keep in mind**
The Unsharp Mask is a generic filter that is provided with most good image-editing packages. Other kinds of sharpening filters, including those applied at source within a digital camera, are much less sophisticated and less reliable.

**04** With the first slider adjusted, the image will have regained some sharpness, but without any attention to shape edges. Sharpness is not just about overall image contrast, but is determined by fine edges between shapes. Fuzzy images have thick edges compared to finely focused ones.

**05** The next step is to adjust the Radius value of the Unsharp Mask filter. The Radius value tells Photoshop how wide the image edges are, which in turn restricts the filter to the areas that need sharpening. Too low a Radius value would result in the edges not being sufficiently sharpened, and too high would result in a posterized effect. Depending on the extent of unsharpness, start the Radius at 10 pixels.

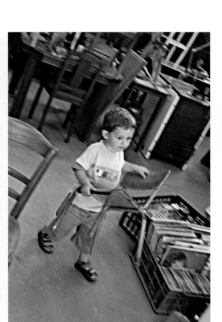

**06** The third and final control found in the Unsharp Mask filter, is the Threshold. When using higher-than-normal Amount and Radius values, the image can start to look pixellated and noisy, but the Threshold slider helps to minimize the problem. If your previous two adjustments have left the images looking "overcooked", move the Threshold slider to 5. The image will go soft, but the trade-off in contrast and hard edges will make for a more flattering end result.

**07** Compared with the starting point we have come a long way in a short time, and have arrived at a much more acceptable version of the image. Sharpening will always be a three-way compromise between contrast, noise, and pixellation, but if carried out in a sensitive manner, can look convincing.

### Sharpening in selection areas

Rather than apply the USM to the entire image at once, you could apply it instead to the more important areas. Make a selection of the area, and apply a feather edge to the selection, so the USM won't suddenly stop at the edge. If you're not sure about keeping the effect, copy and paste your selection into a new layer before applying the USM. This way you can always remove the layer at a later stage if you change your mind.

**Photoshop keyboard shortcuts**
To reset the USM sliders without quitting the dialog box          **Alt + Reset**

**Navigator**
Sharpening                    p86

Repair  045

# Removing unwanted areas

Less-than-perfect compositions can be made visually stronger by removing unwanted areas, using saved selections, and the Clone Stamp tool.

 manipulate it

**01** This image was captured under the canopy of an overhanging tree, but the leaves make it difficult to see the building in all its glory. With such an example, digital pruning is a straightforward process. The first step is to make a selection around the building using the Polygonal Lasso tool. The regular straight-sided shape makes selecting simple.

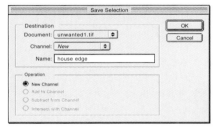

**02** After closing the selection, save the selection so you can reload it at a later stage. With the selection still active, do Select>Save Selection, and give it a recognizable name. Store the selection as a new channel in the current document.

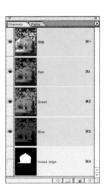

**03** When saved, the selection becomes a special kind of channel, called an "Alpha" channel. Open your Channels palette and confirm that it's been saved by looking at the bottom of the palette. The channel can even be edited to change its shape.

**04** Return to your image and do Select>Load Selection to bring it back into play. Choose the Clone Stamp tool and, working inside the selection, paint away the branches. Pay attention to the sample point. Reuse common items such as the window, edges, and gutters. When removing large areas of original detail, you can end up with an over-edited texture. Clone different textures from other parts of the building to make it less smooth and noticeable.

---

**Technical details**
Nikon D100 digital SLR
Adobe Photoshop 7

**Photoshop tools**
Polygonal Lasso
Save Selection
Clone Stamp
Add Noise filter

**Keep in mind**
Alpha channels, unlike Paths, add a considerable amount of data to your image file. Only keep those selections that you really need to return to or, if there are too many, convert them to the more efficient Paths.

**05** With a tight-fitting selection edge, complete the removal process, then do a Select>Inverse command to flip the selection into the background. Now work outside the building, and tidy up the overhanging branches to make them look natural and not clipped. Once complete, inverse the selection again, and work on the texture.

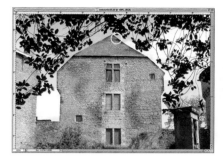

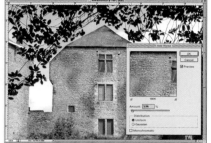

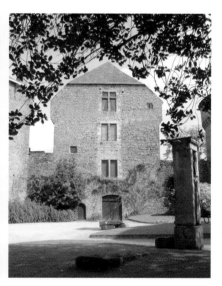

**06** Still with the selection outline in place, use the Burn tool, set with 30 percent Exposure, to darken down a few random edges. Use the tool to introduce a bit of variation into the brickwork and tiles. Use a large brush to avoid streaking.

**07** The final step is to further distress the smooth cloning by adding noise to your image. From the Filter menu, pick the Add Noise filter. Zoom in close to the image and apply small amounts of uniform Noise until it starts to add texture to your brickwork.

**08** With both areas now tidied up, the final result allows all parts of the image to be displayed.

### Hard-edged brushes

An advantage of using hard-edged brushes is that you avoid feathered and diffused Clone Stamping. On close textures, hard-edged brushes cause less of a drop in sharpness than softer-edged tools.

**Photoshop keyboard shortcuts**
To invert a selection          Ctrl/Command + I

**Navigator**

# Combining images

Sometimes an image is 90 percent perfect, but needs an extra boost to remove the imperfections. This technique replaces a washed-out sky with a better one from another image.

## shoot it

**01** Location photography is always at the mercy of ever-changing daylight and, more often than not, the results are disappointing. Once sunlight is obscured by cloud cover, captured images look dull, cold in tone, and flat. This technique aims to replace the dull areas with something better.

## manipulate it

**02** Select the area to be removed using the Quick Mask mode. Use a paintbrush to fill in the areas to be selected until a clean, ruby-colored mask is created. Use a hard-edged brush to make the boundaries of the mask sharp. When complete, switch back to Normal mode, and observe the selection outline.

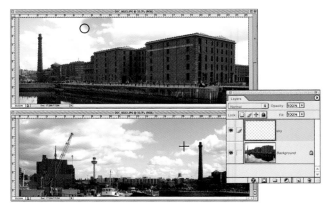

**03** Protect your original image by restricting the edit to a separate layer. Do a Layer>New>Layer command and give it a recognizable name. Make this layer active and leave the background layer untouched.

**04** Open the image that you'd like to clone from, and arrange it underneath, as shown. Use the Clone Stamp tool and clone the good sky into the selection area. Keep a close eye on the bottom image window, or you'll introduce more than you bargained for. Editing inside the selection area will create good, sharp edges.

---

**Technical details**
Nikon D100 digital SLR
Photoshop 7

**Photoshop tools**
Quick Mask
Clone Stamp
Smudge
Duplicate layer

**Keep in mind**
You can easily brighten up a cloud cover shot by adding equal amounts of yellow and red. Use the Color Balance dialog to make the change, and apply the new color into the Highlight area only.

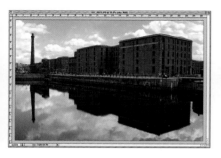

**Reflections**

Invented reflections look much more believable if they are darkened down slightly. Use your Levels command to reduce the intensity of this layer, without increasing the color saturation.

**05** Complete the cloning until the selection area is filled with new sky from the second image file. Vary the position of the Clone Stamp tool, so repeated herringbone patterns are avoided. At this stage in this project, the new sky needs to be reflected in the water.

**06** Duplicate the Sky layer and do an Edit>Transform>Flip Horizontal on this layer. Drag this new sky into position over the water, using the Move tool. Continue with the Clone Stamp tool to add extra areas where needed, or use the Eraser to remove unwanted detail. Make a tight fit.

**07** To make the reflection layer look more convincing, do a Filter>Blur>Motion Blur command. Move the Angle control until the effect is applied in the right direction, and set a 20-pixel blur. The effect will be applied to this layer only.

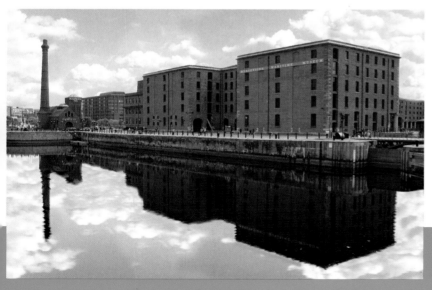

**08** The color of the final result was improved by applying a Color Balance command, adding extra yellows and reds to the highlights. If the borders between sharp shapes in the reflected areas look unconvincing, use the Smudge tool to blend them together.

**Photoshop keyboard short cuts**
Keep Clone Stamp
in a straight line          **Shift + Alt + sample**

**Navigator**
Blurring backgrounds          p50
Making a multi-print          p104

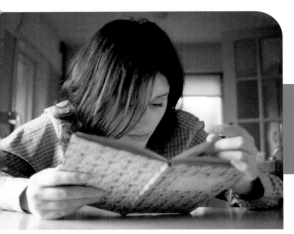

# Blurring backgrounds

Many a fabulous photograph has been rendered less than perfect by a background which draws emphasis away from the main subject.

**02** Although it's perfectly possible to isolate your background by using one of the many selection tools, it's by no means easy. Start off by making a duplicate layer of the background, by dragging the layer icon onto the tiny New Layer icon, found to the immediate left of the Layer Wastebasket. This will make an identical copy of your original, leaving it unaffected and safe from damage.

**03** In the Layers palette, turn off the uppermost layer by clicking the tiny eye icon at its far left. This will allow you to view the background layer. Next, make the background layer active, and do a Filter>Blur>Gaussian Blur command. In the Gaussian Blur dialog, move the slider until the background looks softer, but with still distinguishable shapes. Excessive blurring will make blending sharp and unsharp impossible.

**shoot it**

**01** Although a nice candid portrait, the overall effect is lessened by a busy background. This has been caused by shooting with too small an aperture which, creates a deeper depth of field than was intended. The task is to blur out the background and leave the foreground unaffected.

**Photoshop tools**
Gaussian Blur filter
Duplicate Layer
Eraser

**Keep in mind**
Smaller areas of an image can be blurred away by using Photoshop's Blur tool. Just like any other painting tool, the Blur tool can be set with different brush sizes and is best used with a soft edge.

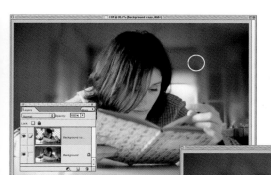

## Shooting shallow depth of field

You can achieve a similar effect in camera by shooting your portrait subject with a shallow depth of field. Set your aperture to f2.8 or f4 and get close to the subject, the background will immediately be out of focus.

**06** The finished result shows a much smoother and less attention-grabbing background. By avoiding the complex cutting-out process, we've also ensured that the seam between sharp and unsharp doesn't look obvious. As this example shows, it's much better to make the background slightly blurred than make it completely indecipherable, as it looks much more realistic.

**04** Next, make active the uppermost layer, and turn the tiny eye icon back on again. The image will immediately regain full sharpness, because the uppermost layer masks out the blurred layer underneath. Next, select the Eraser tool and set it with brush properties, choosing a large, soft-edged brush from the Brush palette. Start at the corners, and gently rub away the sharp layer to reveal the underlying blurred layer, as shown. Don't go near any edges at this stage.

**05** Once the majority of the background has been removed, change your brush to a smaller size. Zoom in to your image until you can clearly see the borderline between soft and sharp, and gently apply the brush right up to the edge. Don't remove any hairlines as these help to create the effect of blending. Work in small areas at a time, and if you go too far, retrace your steps using your History palette. Any overlaps will create a slight halo effect around your subject.

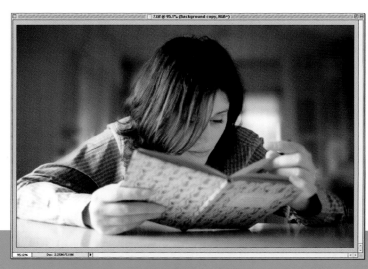

**Photoshop keyboard shortcuts**
To reset the brush size
while working          Ctrl + Click + hold the mouse down

**Navigator**

# Moving items

Arranging all the right elements in a single image can be difficult if they can't be squeezed into a single frame. This technique combines the best elements from two different images.

**shoot it**

**01** This image has a huge "hole" in the center of the frame, and needs another element to make it into an interesting photograph. The image was shot straight on, so makes any montage an easier proposition. The ideal item to introduce is a window.

**02** Shot just around in the corner, but under different lighting, the second source image for the project has the vital ingredient. Make sure that both source files have the same resolution and pixel dimensions, so that any Copy and Paste command yields the same size elements.

**manipulate it**

**03** Open the file to be copied, and select the Rectangular Marquee tool. Check that the No Preset Feather value is set, and drag a selection around the element to be copied. Allow a wide border around the edge, so any shadows and edges are preserved in the copy.

---

**Technical details**
Nikon D100 digital SLR
Adobe Photoshop 7

**Photoshop tools**
Copy and Paste
Transform
Eraser
Guides

**Keep in mind**
The Eraser is a very versatile tool that can look obvious if used with the same properties throughout an edit. Mix up your erasing by changing the brush size and hardness, and your cut lines won't look too smooth and perfect.

**04** Do an Edit>Copy, then close down this image document. In the main image, do an Edit>Paste command, and notice that this will automatically create a new layer. Floating above the background layer, this new layer will be subjected to all the editing, while the underlying original is preserved.

**05** Use the Move tool to drag the new window into position, then take a minute to decide on the scale. Use the Edit>Transform>Scale command to resize the new window. Hold down Alt + Shift, and drag one of the corner handles inwards to reduce from the center inwards. Press Return when you are satisfied with the edit.

**06** Select the Move tool, and pull four (non-printing) guides around the edge of your shape. Next, use the Eraser tool to gently remove the sharp edge from this pasted shape, until it starts to blend in with its surroundings. Leave any interesting textures, lines or features intact, even if this makes an irregular shape.

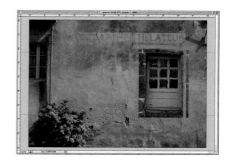

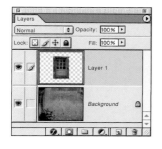

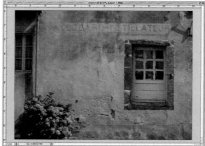

### Color correction
To merge very different source images, you may need to color-correct at least one of the elements. Use your Variations dialog box to cancel out any differences.

**07** Finally, use the Lasso tool to drag a loose selection around one side of the window to create a shadow effect. Apply a Feather edge to the selection, then use the Levels command to darken down the selection. The fake shadow creates the illusion of depth. With an extra element now introduced, the photograph is stronger and much more interesting.

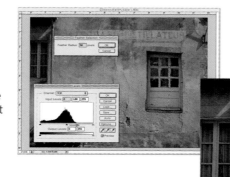

**Photoshop keyboard shortcuts**
Hide/Show guides
and selection edges        Ctrl/Command + H

**Navigator**
Print papers        p96

# Straightening horizons

Caught off-guard by an overpowering subject, it's easy to lose concentration. Yet with a few simple Photoshop moves, even the most uneven horizon can be straightened out.

shoot it

**01** As is often the case when shooting tall buildings, it's easy to lose sight of the horizontal aspects of your composition. Although fairly straight and central, this scene is falling over the left-hand side because the camera was tilted by accident.

manipulate it

**02** The first step is to make a new empty layer, so any paint-editing can be restricted to this layer. This technique involves increasing the Canvas Size of the image, so it's useful to keep this separated from the original data.

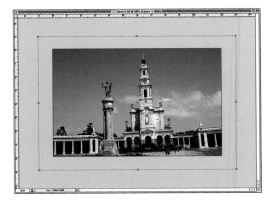

**03** Select the Crop tool and drag it around the perimeter edge of the image. Zoom out and make sure you arrange your image window so you can see the entire edge of your file, plus plenty of extra gray space. Once arranged around the perimeter, drag each corner handle outwards until arranged as shown. This creates additional canvas space, but in a more visual manner.

---

**Technical details**
Nikon D1 35mm SLR
Nikon Coolscan film scanner
Adobe Photoshop 7

**Photoshop tools**
Rotate
Clone Stamp
Crop

**Keep in mind**
When images are turned too much through a Transformation command, they lose their parallel sides. New edges need to be re-established to maintain the pixel dimensions of the image, or a smaller image can be made by removing with the Crop tool.

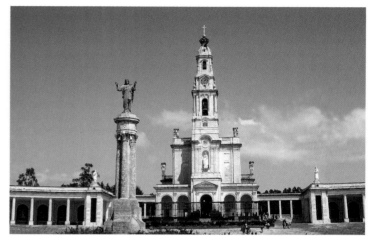

**04** Select the Move tool, and make sure that the rulers are visible in the image window. Click in the Ruler margin and drag blue non-printing guides into your image and arrange them along prominent horizontal and vertical axes. These will help you to rearrange your horizon.

**05** Make the image layer active, and Ctrl/Command click into the Layer icon to select the image. Next, do Edit>Transform>Rotate, and move the top-right corner until the image lies in a corrected position. Use the blue guides to judge when to stop rotating. After this command, the image edges will not be straight.

**07** The final result shows the main subjects standing straight on a flattened-out horizon line. With the previous distractions now removed, the image can be viewed without distortion.

**06** Drag the blue guides to the two edges of your rotated image, to provide a new guide. Next, make a Rectangular Marquee selection within this new shape, and use the Clone Stamp tool to build up the image in the new layer. With graduated colors, as found in this sky, be careful to set your sample point on a horizontal straight line to the painting point, to ensure that the retouching looks convincing.

**Cloning gradients**
Only experience will improve your cloning skills, but gradient colors are the hardest to match, even for an expert. Gradients are tricky because they change color and brightness over a short distance, which needs to be matched perfectly by accurate sampling.

**Photoshop keyboard shortcuts**
Free Transform tool      Ctrl/Command + T

**Navigator**
Building up missing detail    p78
Enlarging and resizing    p84

# Perspective distortion

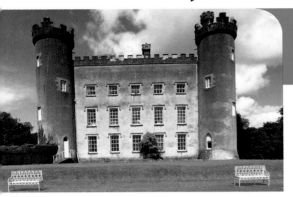

The higher you point your camera lens, when trying to capture tall buildings, the more distorted perspective will become. You can level this problem in a few simple steps.

manipulate it

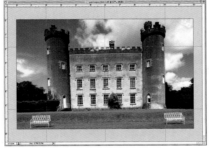

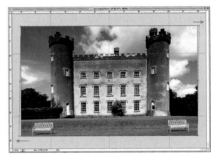

**shoot it**

**01** This example of a fine Irish castle was shot with a zoom lens set to its wide-angle setting. The result is an unnerving twist and distortion, which makes the left-hand tower look like it's about to fall over. Both vertical and horizontal axes are easily put straight, using a few simple steps in Photoshop.

**02** From the View menu, select the Rulers option. Next, pick the Move tool from the toolbox, and position this inside the vertical ruler margin. Click and hold, then drag away a blue, non-printing guide. Make three guides: one on the exact center of the image, and the other two at either end of the building. These guides will help to correct wonky verticals. Repeat the process for the horizontal edges.

**03** Don't try to correct everything at the same time, or you might increase distortion. Do Select>All, then Edit>Transform>Distort. Correct the verticals first by pushing the corners outwards, until the edge of your building lines up with both blue guides. Your desktop window will take some time to refresh after this command.

## Instant result
You can also create extra space around an image by using the Canvas Size command, but you can't see the end result until you commit to the edit. A much better option is to us the Crop tool, to get an instant visual result around your image.

**Photoshop tools**
Transform>Distort
Clone Stamp
Guides
Rulers

**Keep in mind**
Although the Transform>Perspective tool is effective for fixing distortion in either vertical or horizontal planes, it can't do both at the same time. With most images, there's usually more than one edge that needs adjusting, so the more flexible Transform>Distort tool is a better bet.

**04** Once you're happy with the verticals, try your luck with the horizontals. Make sure you've got enough empty gray window space around your image, as you'll need to see the corners of the Distort tool. Move the corners, as shown, until all the horizontal lines have been straightened out.

**05** After this initial redrawing of the image, it is likely that some areas of the image were cropped off. The second stage of the process is to put back some of the missing image areas using the Clone Stamp tool.

**06** Pick the Crop tool from the toolbox, and make sure white is set as your current background color. Drag the Crop tool around the entire image and let go. Next, pull up the top-middle handle and pull down the bottom-middle handle for a couple of centimeters each. Press return and notice how extra canvas size has been created.

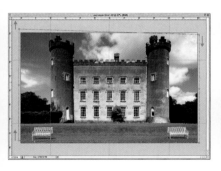

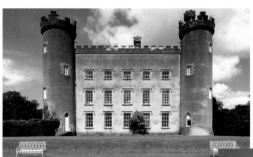

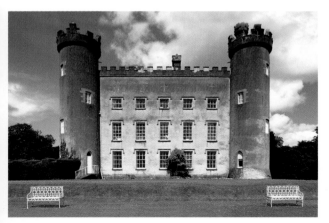

**07** Use the Clone Stamp tool to rebuild the new white Canvas areas until the image looks less constricted by a tight-fitting edge. Avoid creating noticeable herringbone patterns by regularly changing sample points.

**08** The final image looks balanced and corrected, and does the original building more justice. Make a Color Balance correction before going to print.

---

**Navigator**

**Photoshop keyboard shortcuts**
To give the Distort tool
perspective properties    Ctrl + Alt + drag a corner

CHAPTER THREE

# RESTORATION

# Improving contrast

You can easily liven up a dull and lifeless image by using Photoshop's advanced contrast correction, or Curves tool.

shoot it

manipulate it

**01** Most digital cameras produce images that have a deliberately flat contrast due to negative influence of the built-in anti-aliasing filter. Flat-contrast images never do the original scene much justice, but you can easily make things better using the Curves controls.

**02** Open your image and check the contrast levels by examining the Histogram, found under Image>Histogram. Like the Levels dialog, this shows where the maximum values of blacks and whites are situated. This image was shot on a misty morning, and there's no rich black or pure white.

**03** Go to the Curves dialog (Image>Adjustments>Curves). Ensure the drop-down Channel menu shows RGB, and that the scale shown at the base of the graph has black to the left, white to the right, as shown. If your scale is back to front, click on the tiny triangles in the center to change it.

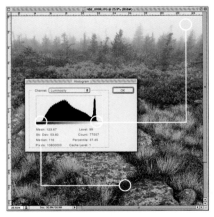

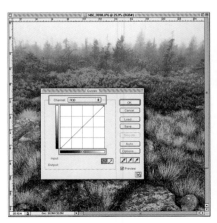

**Technical details**
Nikon D1 SLR
Adobe Photoshop 7

**Photoshop tools**
Curves

**Keep in mind**
You can use the same technique for lightening up a portion of your image rather than the entire area. Make a selection first and then take your sample point from inside.

**06** With your Curves dialog still active, click a third point on the center of your curve, shown here by the red circle. This will keep your midtones fixed while you move highlights and shadows. Next, push the sampled highlight point up and pull the sample's shadow point down, until you make a gentle sloping "s", as shown.

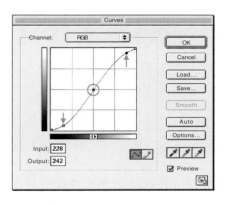

**04** Now, to make the lightest tones brighter, you need to sample the lightest tone from your image, and set it on the Curves graph. With your Curves dialog open, drag your cursor into the image, and place it over the brightest area. Press the Command/Ctrl key and click with your mouse. A tiny black dot will now appear on your curve.

**05** The next step is to repeat the previous command, this time targeting the black point. Drag your Curves dialog box out of the way if you need to, then sample the blackest point you can find. Your curve now has two sample points for contrast manipulation.

**Deselecting sample points**

If you introduce a sample point by mistake, you can simply deselect it from your Curve by placing the cursor over it, holding down the same Command/Ctrl key and then clicking.

**07** The final result shows a much brighter and punchier image, without ruining the original lighting atmosphere. Severe manipulation of Curves makes for a posterized and high-contrast end product.

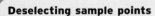

**Photoshop keyboard shortcuts**
Step back to compare the previous state   Alt + Z
Step forward again   Shift + Z

**Navigator**
Print papers   p96
Creating emphasis   p80

# Making high-contrast prints

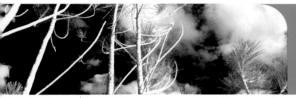

If you'd like to add a touch of dramatic contrast to your images, then you can easily raise the stakes, using both color and monochrome techniques.

## Color manipulation

shoot it

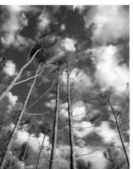

**01** Unless you're shooting with a digital SLR, fitted with a polarizing filter, you'll never get deeply saturated skies. Polarizing filters work by restricting the passage of certain wavelengths of light, making some colors darker or lighter than they are in reality. You can easily mimic this effect in Photoshop by one of the following two methods.

**manipulate it**

**02** Open your image and make all necessary color and tonal adjustments as usual. Next, from the Image>Adjustments menu, choose the Selective Color option. When the dialog opens, choose the Blues option from the top Colors drop-down menu. This is chosen because we want to make the blue sky darker. Move the Black slider to +100 percent

**03** The final result, after the addition of 100 percent black, shows all the blue areas much darker. Without needing to make a selection around the sky—a difficult task—the Selective Color command works on unconnected pixels of a similar color.

---

**Technical details**
Nikon D100 SLR
Adobe Photoshop 7

**Photoshop tools**
Selective Color
Channel Mixer

**Keep in mind**
If your image is dark after a Channel Mixer adjustment, use the midtone slider in the Levels dialog box to lighten up the end result. Don't apply many more creative corrections, or you'll "overcook" the image.

# Monochrome manipulation

manipulate it

**01** A very special technique can also be used for converting color originals, whether they are shot or scanned into atmospheric mono. Keep your image in the RGB mode and use the command Image>Adjustments> Channel Mixer. Click on the Monochrome option at the bottom left-hand side of the dialog.

**02** Your image will now appear as mono, but is in RGB mode. Keep the dialog open and move the Red slider until it reaches +200. The purpose of increasing red is to try and mimic the effect of a deep-red photographic filter, a traditional technique for making blue skies reproduce darker. Don't worry if your image suddenly starts to white-out.

**03** While still in the Channel Mixer dialog, now move both Blue and Green sliders until they reach -50 on the scale. There are no official recommendations concerning the precise mix of colors but, as a general rule, try to ensure that the three values add up to +100. This figure can include negative values, too.

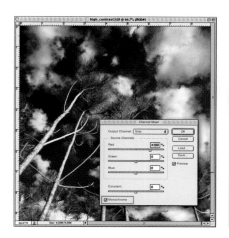

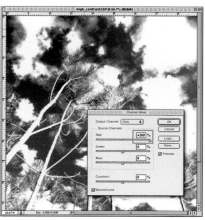

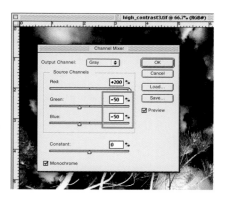

## Printing tips

With high-contrast images, avoid any dark grays as they will turn into rich blacks when printing, losing vital details. Choose a high-gloss paper as this will reproduce the widest tonal range.

print it

**04** The finished result looks more dramatic than the enhanced-color version of the same image, opposite. To make the result more stylish, print out with a black border, by increasing your Canvas size and then doing a Select>All, Edit>Stroke using black set to a width of 8 pixels.

**Photoshop keyboard shortcuts**
Reset dialog box
without quitting          Command/Ctrl + Reset

**Navigator**
Borders and edges      p100
Color balance          p94

# Making low-contrast prints

Unusually for color images, digital photography gives you the opportunity to reduce both the intensity and contrast to create stunning effects.

## shoot it

**01** There are two methods for draining contrast and color intensity away, and both use a simple Photoshop technique. Shoot your image and make your normal color corrections. Choose a strong color image that would benefit from this effect.

## manipulate it

**02** From the Image>Adjustments menu, choose the Hue/Saturation option. This versatile dialog offers the chance to change both color and color intensity. Make sure the Preview option is checked, so you can see the effects on your image window behind the dialog. Click on the Saturation slider and push it to the left to drain color away.

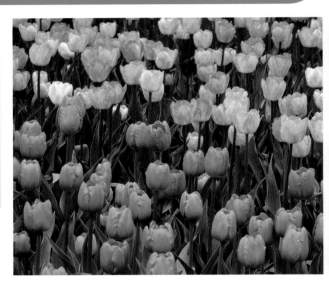

**03** As you push the Saturation slider further to the left, more color is drained away from your image, until it eventually turns monochrome. Aim for a faint but delicate effect, where some color is still visible. If you want to put color back, use the Sponge tool on Saturate at 50 percent, with a soft-edged brush. Gently apply the brush to smaller areas of your image

---

**Technical details**
Umax Powerlook Scanner
Epson 2100P pigment
inkjet printer
Adobe Photoshop 7

**Photoshop tools**
Levels
Hue/Saturation

**Keep in mind**
When using printer software, avoid using any Auto or Photo Enhance settings, as these could introduce a contrast increase without you knowing it. Try to work with manual settings only, and you'll keep control over every stage of your output.

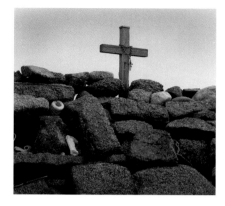

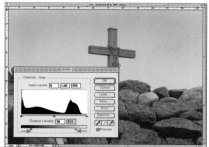

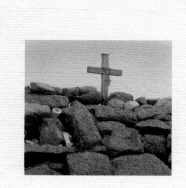

**02** Bring up your Levels dialog and manipulate the Output Levels scale, found at the base of the dialog, rather than the normal Input Levels. There are only two sliders in the Output scale—highlight and shadow— so pull both inwards to the center.

**01** For a monochrome image, the process of reducing contrast uses a simple Levels adjustment. Make a scan of your print and prepare it at normal levels of contrast. Ensure there is plenty of detail visible in shadow areas, or the printing process will further reduce it.

**03** The result of the Levels Output edit is a reduction in both the depth of the black shadows and the brightness of the highlights. With new points now set, this creates a softer kind of image. Just like a fine-quality darkroom print, a low-contrast file is now ready for printing.

print it

**04** Low-contrast prints look sensational if output onto off-white, uncoated printing paper. Avoid the shiny plastic or glossy inkjet papers, and opt for a 100 percent cotton material such as Somerset Velvet or Hahnemuehle. This example was printed on Conqueror writing paper, to gain a hand-crafted, laid texture.

**Printer settings**

When printing out on absorbent papers, prints can emerge looking heavy and darker than expected. To avoid this, try experimenting with different media settings in your printer software until a perfect match is found. Plain Paper setting is a good starting point, together with 360dpi or 720dpi printer resolution

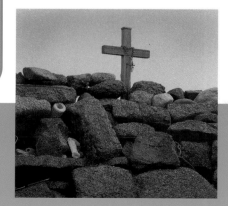

**Navigator**

# Restoring tone

You can easily bring back the subtle sepia tone of a vintage print using Photoshop's sophisticated toning tools.

## scan it

**01** Vintage prints often lose their original sepia tone, or start to look patchy if they've been allowed to sit in the sun for many years. If in doubt, scan them in the Grayscale mode rather than RGB, and all traces of color will be removed, leaving you to put it back again digitally.

## manipulate it

**02** Make sure all tonal corrections are carried out before you apply the new color. If you're working on a vintage print, try to retain its original softer tonal range rather than correcting it, as it will look much more realistic. Use your Curves dialog to soften contrast, as shown, then change the image mode to RGB.

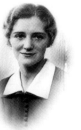

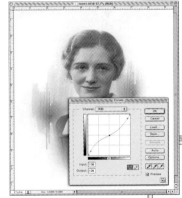

**03** Next, command control Image>Adjustments>Color Balance, and make sure both Preserve Luminosity and Preview are selected. Although used primarily to correct color imbalance, the Color Balance dialog offers a great way to add tone independently to three tonal sectors.

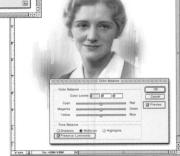

**Technical details**
Umax Powerlook
flatbed scanner
Silverfast
Adobe Photoshop 7

**Photoshop tools**
Color Balance
Variations

**Photoshop keyboard short cuts**
Increase values
in Color Balance dialog    **Click on slider + Arrow up**
Decrease values in
the Color Balance dialog    **Click on slider + Arrow down**

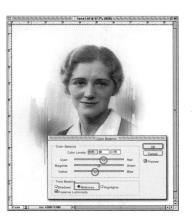

**04** Make sure the Midtones Tone Balance option is checked, as this will allow you to introduce new color into the midtone areas of your image. Next, move the Red slider to the right, and the Yellow slider to the left, as shown. This command will create the start of a sepia tint. Don't overdo the intensity of color at this stage.

**05** Without quitting the Color Balance dialog, click the Highlight Tone Balance option to work on your image highlight color. For this command, add a tiny amount of yellow to the highlights by moving the slider to the left, as shown—too far will turn all whites an acid yellow.

**06** Finally, select the Shadow Tone Balance option to deepen the sepia color in the shadow areas. Apply a generous amount of red to the shadows by moving the Red slider to the right until a noticeable difference occurs. If you push this value too far, your image will look posterized and unrealistic.

**07** The final result shows a delicate image color, without any flattening or increase in tonal value. Better than the Hue/Saturation Colorize command, this process allows you to dictate a much more sensitive color arrangement.

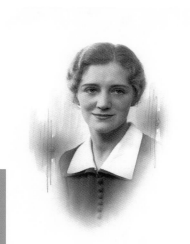

### Using the Variations dialog

If you can't decide which tone to color your image with, try using the Variations dialog box. Found under Image>Adjustments>Variations, the full-size dialog box offers you a visual comparison of different colors side by side. In addition to setting color in highlights, midtones and shadows, you can also control color saturation.

**Navigator**

# Restoring faded slides

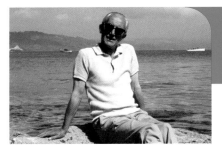

Transparencies that have faded, due to age or exposure to light, can easily be restored to their original color intensity.

 **manipulate it**

**02** Once scanned, remove dust and scratches using the Clone Stamp tool.

**scan it**

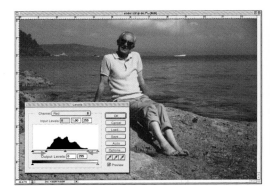

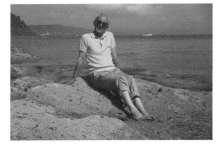

**01** Pick a faded color transparency and make an RGB scan using a film scanner. Avoid increasing contrast or manipulating Levels in the scanner software, unless you've got a high-resolution preview.

**03** Open the Levels dialog and look at the composite RGB Channel, found at the top of the Channels pop-up menu. In this example, the black mountain shape indicates that little color information is available outside the midtones, perfectly describing the flat and faded image.

**04** Next, click the pop-up menu and choose the Red channel. The black mountain shape will change because you're now looking at the spread of reds in your image. Like the composite RGB channel, there's no full-value red in the entire image. Move both shadow and highlight triangles inwards, as shown, and observe a slight color change.

---

**Technical details**
Minolta Dimage
film scanner
Adobe Photoshop 7

 **Photoshop tools**
Levels editing in
color channels

 **Keep in mind**
Don't rule out the palest or most faded originals, as they can all be rescued by the Levels controls.

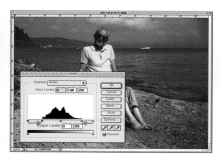

**05** While still in the Levels dialog, choose the Green channel from the pop-up menu. Like the previous Red channel, there's little full green present in the faded slide. Pull both highlight and shadow points inwards towards the center, until they both rest on the outer slope of the peak. Don't pull the sliders any further inwards.

**06** Finally, choose the Blue channel and notice how much narrower the spread of this color is in the faded slide. Again, move the highlight and shadow sliders inwards until the image miraculously regains its original color. This third Levels command will correct any color imbalance in the image.

**07** A final correction pushes the brightness of the image up until any details lurking in the shadow areas are revealed. In the Curves dialog, work on the composite RGB channel, and click a point on the center of the graph. Click and hold this point, then push upwards until a gentle arc is created. Move the dialog to one side and check your edit.

### Cleaning dusty slides

Ancient slides attract dust and other fibers like no other kind of photographic original. If your family heirlooms have not been kept in glass slide mounts, they will probably need a good clean before scanning. Although it's easy to remove dust and scratches with the Clone Stamp tool, try and remove as much as you can before scanning using a photographer's blower brush.

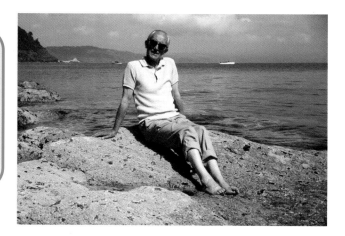

**Photoshop keyboard shortcuts**
To open the Levels dialog box    **Command/Ctrl + L**
To work on the Red channel    **Command/Ctrl +1**
To work on the Green channel    **Command/Ctrl +2**
To work on the Blue channel    **Command/Ctrl +3**
(works within the Levels dialog box only)

**Navigator**

Scanning    p14
Making cut-outs    p82

# Restoring damaged prints

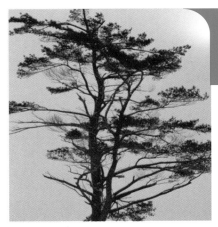

Even drastic physical damage can be removed by software trickery, together with plenty of patience.

manipulate it

**02** From the Image>Adjustments menu, choose the Replace Color option. Drag this to one side of your image window, so your target damage is not obscured. In the dialog box, make sure the tiny Selection option, found under the preview image, is checked. This shows your selected colors as white against the non-selected colors, reproduced as black.

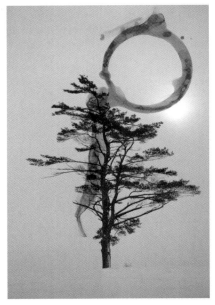

scan it

**01** This print was damaged by a cup of coffee, leaving a nasty brown stain, but it can be removed by careful filtering. It's important to retain the color information in the image, which helps removing it later on. Scan in RGB mode and avoid increasing contrast.

---

**Technical details**
Umax Powerlook
flatbed scanner
Adobe Photoshop 7

 **Photoshop tools**
Replace Color

 **Keep in mind**
If you sample color from an image when using the Replace Color dialog, even the slightest change in your sample position can make a difference. If you get unexpected results, zoom in closer to your image and make a more accurate choice.

**03** Drag your cursor into the image window and click on a midtone value within the damaged area. This will now show up as a white shape in the dialog box preview window. Move the Saturation slider to the left until the stain starts to disappear or becomes less prominent. Don't attempt to remove the entire mark in one go.

**04** Return to the dialog box and pick up a different part of the offending stain with your Dropper tool. This time, try a combination of Hue, Saturation, and Lightness edits until the stain color disappears. Even the slightest change to the Hue value will create a color cast on your image, so use this sparingly. If you find other areas of the image are included by mistake, then reduce the Fuzziness slider until the preview image shows only the parts you aim to remove.

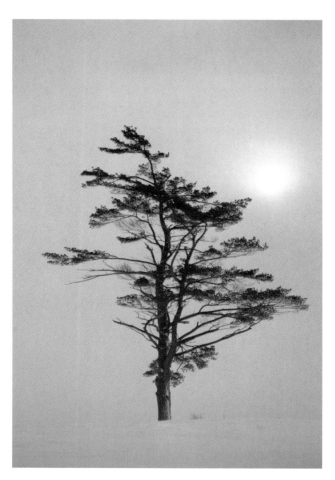

**Fuzziness**

Like the Tolerance value with Photoshop's Magic Wand tool, the Fuzziness slider in the Replace Color dialog offers an opportunity to increase or decrease the number of like colors held in the selection. With the Selection option checked, the white image in the tiny preview window will expand and contract with your Fuzziness adjustment.

**05** Work through the project, bit by bit, until you've removed all traces of the unnatural color from your original print. Work on different tones first, until each tiny blotch is painstakingly removed. This technique is useful when it's impractical to retouch unwanted areas due to complex surrounding shapes or gradients.

**Photoshop keyboard shortcuts**
(Works in the Replace Color dialog only)
To remove a color from the selection      **Alt + click**
To add a color to the selection              **Shift + click**

**Navigator**

# Painting with color

There's no reason why you shouldn't experiment with sophisticated color editing if you know the right tools to use.

**shoot it** 📷

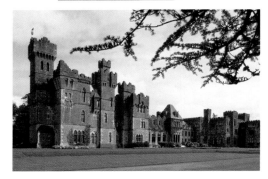

**01** This image was shot with a digital compact camera without the use of a graduated filter which would have helped to darken down a pale sky. Yet there's no reason why a delicate color gradient can't be introduced in Photoshop afterwards.

**manipulate it** 🔍

**02** Pick the darkest blue color from your image using the Eyedropper tool and set the foreground color to blue. Next choose the Gradient tool.

**03** Change the Gradient tool properties to the Linear Gradient, 40 percent Opacity, with the Multiply Blending mode. This will introduce new color to white areas. Change the Gradient type in Foreground Color to Transparent–this mimics a photographic graduated filter.

**05** Using this blending mode, you can easily introduce more saturated color without removing any underlying image detail. Use the Color Blending mode if you want to change existing color rather than remove white.

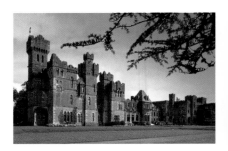

**04** Drag the Gradient tool several times across your image in the direction of the red arrows. Don't overextend the Gradient into non-sky, or you'll easily spot the new color.

---

**Technical details**
Nikon 775 digital
compact camera
Adobe Photoshop 7

**Photoshop tools**
Gradient tool
Gradient editor
Sponge tool

**Keep in mind**
Any time you shoot into the sunlight, you're bound to get a washed-out sky or a darker than expected ground. Graduated filters can help to even up these differences in exposure.

**01** If your images look bland and unspectacular, you can easily bump up the color intensity of specific areas by using the Sponge tool. This image looks washed out, but has some vibrant reds that can be enhanced.

**02** Choose the Sponge tool from the toolbox. If it's hidden, click and hold the Burn or Dodgtool until the pop-out menu appears.

**03** Set the tool to work with Airbrush properties at 40 percent, and with the Saturate option. Finally, choose a large, soft-edged brush.

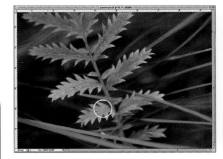

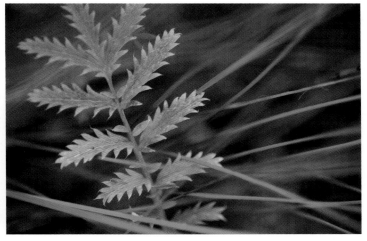

**Creative coloring**

Color-blending modes are not just intended for editing with Layers, they can be used in conjunction with color too. Even Edit>Fill, Edit>Stroke and the Fade filter commands can be applied with an element of creativity.

**04** Press the Sponge down on to the weak areas you'd like to make more vivid, and drag your brush over the shape. If you repeat the same stroke, you'll increase color saturation.

**05** The end result shows a delicately enhanced image which has had the Sponge tool dragged across the weak reds. Remember, all colors will be enhanced to the same degree using this method, so if you want to restrict your edit to a particular shape, try applying it to a selected area.

**Photoshop keyboard shortcuts**
Laying down a gradient in a straight line     **Shift + drag**

**Navigator**
Color balance          p94
Print papers           p96

# Restoring hand tints

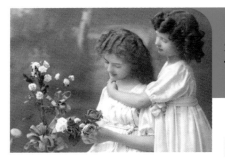

Many vintage family photographs were hand-tinted, using less stable inks, which fade easily in daylight. You can easily restore this effect using the Color Blending mode.

## scan it

**01** Even if there's a substantial amount of color in your original print, don't scan it in the RGB color mode, but as a grayscale instead. Capturing in grayscale will remove all traces of color, so you can start with a clean slate. After scanning, convert to RGB color mode.

## manipulate it

**02** For this tool to be most effective, it's important that your image is light- rather than dark-toned. After your scan, change the tonal range of your image using the midtone slider in the Levels dialog. Make it a bit brighter than you would normally, changing the gamma value from 1.00 to 1.25.

**03** Bring up the Swatches palette and position it on your desktop, so you can see your image clearly. Unlike the Color Picker, the Swatches palette stays on your desktop at all times for quicker color selection.

**04** Choose the Paintbrush from the toolbox and set it with a soft-edged brush from the Brush options palette.

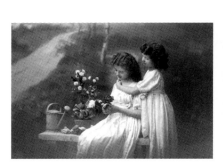

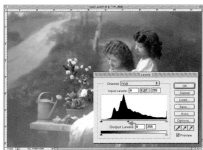

---

**Technical details**
Umax Powerlook scanner
Silverfast

 **Photoshop tools**
Paintbrush

 **Keep in mind**
You can't "mix" colors in the traditional sense when using the Color Blending mode, as new color seems to remove the one it is placed over. If you want to experiment with mixing Swatch colors, try using the Mulitply mode.

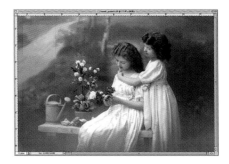

**05** Give the Paintbrush extra airbrush properties with 100 percent Flow, and set it to Color Blending mode. This mode allows you to paint while still preserving underlying image detail.

**06** With the Color Blending mode, if an identical color is introduced at different opacities, the results will be very different. This image shows the same color entered in four different opacity values. Starting from top-left is 100 percent, 80 percent, 40 percent and finally 20 percent. Set your brush to 40 percent to begin with.

**07** Start by filling the entire image with a sepia color chosen from the Swatches and entered using an Edit>Fill command. Choose the same Color Blending mode from the Fill dialog box and set it to work with 40 percent opacity.

**08** Work on smaller areas with similar colors first. You'll need to change your brush size and zoom in to avoid making obvious overlaps. If you want to increase the strength of your color, simply apply it in two coats. Even if you make a mistake, you can easily remove color by simply painting over it with a new choice.

**09** The finished result shows a sensitive, hand-tinted effect that has enhanced the already timeless image. Try to avoid very bright colors and an excessively varied palette to stay within the traditional look and feel of a vintage print.

**Other swatches**

Hidden deep in the Swatches pop-out menu is a great assortment of other preset Swatches palettes. Simply click on the tiny black triangle at the edge of the palette, and choose from one of the many options. Although the Pantone palettes offer an enormous range of different colors, remember that they are less compatible with inkjet output.

**Photoshop keyboard shortcuts**
Change brush size
while you paint          **Ctrl + press brush down**

**Navigator**
Scanning small originals          p20
Painting with colour          p72

CHAPTER FOUR

# ENHANCEMENT

# Building up missing details

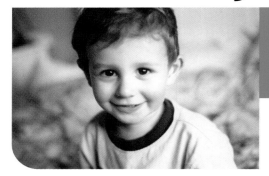

If you've accidentally cropped the top off a favorite portrait when composing in the viewfinder, don't despair, as you can easily paint back the missing details.

scan it

**01** This color photographic print captures a perfect expression, but falls short because of the clumsy composition. When faced with a fleeting photo opportunity, it's easy to lose sight of your image edges. To rectify this, start by scanning your print at 200ppi.

### Better cloning
The secret to convincing use of the Clone Stamp tool is to keep changing sample points at regular intervals. If left unchanged and kept at the same distance from the painting point, obvious patterns will soon appear.

manipulate it

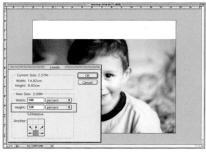

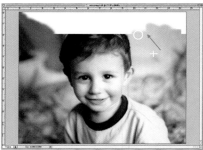

**02** To add more detail at the top of the image, you need to increase your Canvas Size to accommodate it. Make sure your Background Color is set to white, then do Image>Canvas Size. In the Anchor panel, click the central square on the bottom row, then increase the height of your image to 120 percent.

**03** Select the Clone Stamp tool and set it with a large, soft-edged brush, with 100 percent opacity. Make your sample points from unfocused areas of your original image, and use these to build up your white background area. Be careful that your sample point doesn't stray into the wrong area by mistake.

**Technical details**
Nikon F4 SLR film camera
Umax Astra scanner

**Photoshop tools**
Clone Stamp
Blur

**Keep in mind**
New Canvas area is always created using the current background color, so it's important to set this to an easy-to-see color. Although this will be overpainted and removed by cloning, white or 50 percent gray is much easier to work with.

**04** Fill in the background as best you can, then examine carefully for repeating patterns. Excessive use of the Clone Stamp tool will result in visible herringbone patterns, but these can be removed by resampling another area and overpainting. If needed, use the Blur tool to soften down any distracting shapes.

**05** Next, select a smaller Clone Stamp brush and start building up the missing detail. Try and follow the lines and tones of your shape by positioning your sample point carefully. If you are making a sweeping stroke to the right, make sure your sample is set to the left of your starting point. Don't worry at this stage if the edges are fuzzy.

**06** To correct soft edges, go to the brush menu and select the Dune Grass brush. Shaped like a strand of hair, this is used to introduce a realistic hair edge to your new head of hair. Click on the Brushes Presets and modify the shape, size and angle of your brush.

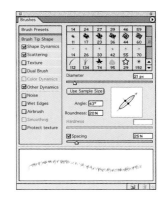

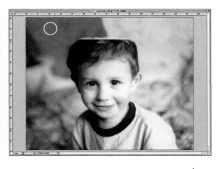

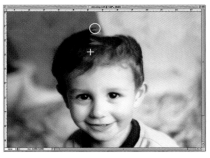

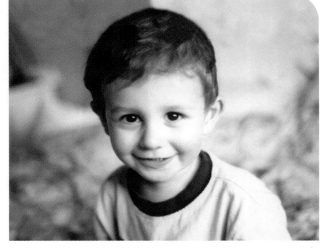

**07** Use the Dune Grass brush with the Clone Stamp tool and introduce a random hair edge. As you move around the shape, you'll need to change the orientation of the brush. Go back to the Brushes Presets window and alter the Angle by dragging the elliptical shape.

**08** The final result looks convincing because the tell-tale soft edges of the Clone Stamp tool have been minimized. Compared to the original starting point, a much better composition has been achieved, long after the shot was taken.

**Photoshop keyboard shortcuts**
Changing brush size while working

Setting default foreground and background colors
Switching between foreground and background colors

Ctrl + click will open the Brushes palette

D

X

**Navigator**
Removing unwanted areas    p46
Scanning color                      p18

# Creating emphasis

Dull and dreary images do not scream out to be printed, yet with a few simple moves, they can be brought back to life.

manipulate it

shoot it

**01** Changing light conditions make achieving perfect lighting notoriously difficult in landscape photography. This image, shot on a top-quality digital SLR, has muddy colors, a burned-out sky, and doesn't do the dramatic scene justice.

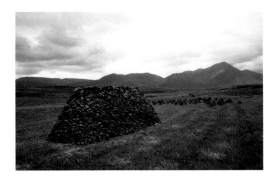

**02** The first step is to brighten the image by using the Levels command. From the Image>Adjustments menu, choose Levels, and drag the dialog into an empty area of your image window. Move the Midtone slider slightly to the left, as shown. This will immediately lift the ground and make the colors brighter. Press OK.

**03** Next, it's important to increase the color saturation, so that the later edit, using the Channel Mixer, will look even more striking. Choose the Hue/Saturation slider and choose Green from the drop-down Edit menu. Move the Saturation slider to the right, until your greens are enhanced without looking false. Repeat the edit on the Yellow colors until the grass looks more vivid.

**Removing selection edges**
Removing the visible edges of a selection area can make it easier to judge the amount of an edit to apply. Simply View>Extras, or Command/Ctrl + H. Don't forget to make a Select>Deselect before moving onto your next edit.

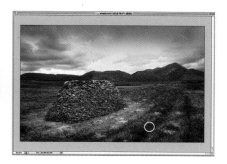

**04** From the Image>Adjustments menu, choose the Channel Mixer, and click on the tiny Monochrome button, found at the bottom-left-hand corner of the dialog. Next, remix the original color values by making Red +200, and both Blue and Green -50. This will immediately create a moody, monochrome version of your muddy color image.

**05** To correct the white patches in the sky, use the Magic Wand tool, set with a low-tolerance value of 20. Click in the white sky area and then apply a Select>Feather command to soften the edges. Once selected, do an Image>Adjustments>Brightness/Contrast command. Gently, pull the Brightness slider to the left, to darken your selection down.

**06** Select the Burn tool from your toolbox and set it to a 200-pixel, soft-edged brush. In the Options menu, reduce the Exposure slider to 40 percent, and set it to work in the midtones only. Gently, apply the brush to the sky and land areas, emphasizing any naturally occurring lines and shapes. Try and darken down the perimeter edges of the image to draw attention to the central elements of your composition.

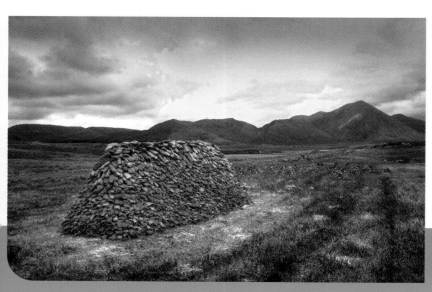

**07** Finally, add a touch of tone to your cold monochrome image using the Hue/Saturation dialog box. Click on the Colorize button at the bottom right, and follow this by moving the Hue slider left or right until you've found the right color.

**Navigator**

# Making cut-outs

Many family portraits can be improved by cutting them out from unflattering backgrounds using a technique much favored by wedding photographers.

manipulate it

Feather Selection

Feather Radius: 25 pixels    OK    Cancel

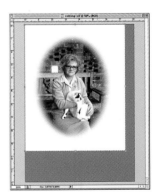

scan it

**03** After inverting the selection, soften down the edge of the forthcoming cut. Do a Select>Feather command, and wait for the Feather dialog box to appear. Set the Feather value to 1 percent of the pixel width of your image (e.g. 1 percent of 2,500 pixels is 25 percent). This creates a soft, clean edge that won't overlap into your image.

**01** This vintage family image was shot on color slide film and has lost some of its original sparkle. In addition to the unfortunate color change, dreary winter light does nothing for the atmosphere. When scanning film originals, capture at a high resolution, such as 2500ppi, to pull out as much detail as possible.

**02** Open the image in Photoshop and choose the Elliptical Marquee tool. Drag this in an oval shape to create a pleasing crop around your subject. If you need to move the selection, position your cursor inside the shape and click drag. When positioned correctly, do a Select>Inverse command.

**04** Next, do Edit>Cut and watch how your unwanted background has now been removed. Now, recompose your image using the Crop tool to drag a new perimeter edge around your oval-shaped portrait. Don't crop too tightly around the sides, but leave an even gap. Press Return to confirm the crop.

**Technical details**
Nikon Coolscan film scanner
Adobe Photoshop 7

**Photoshop tools**
Marquee
Crop
Dodge

**Keep in mind**
You can achieve a similar effect with the Sponge tool set to Desaturate, but this will drain bright color away rather than alter the brightness of surrounding areas.

**05** After cropping, select the Dodge tool from the toolbox. Set it to a large, soft-edged brush size such as 100 pixels. Most importantly, change the Brushes properties to paint in the Midtones with a 50 percent Exposure value. This will make the forthcoming edit less drastic.

**06** Now, drag the Dodge tool around the remaining background areas of your image to reduce its dominance. Work from the outer edges inwards and aim to drain dark colors away, as shown. If you go too far, use your History palette to retrace your steps.

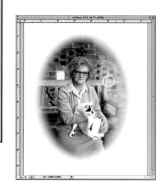

**07** Finally, double the size of the Dodge tool brush and work gently on the outer edges of your oval to further blend in with the white background. If you take too much away at once, try reducing the 50 percent Exposure value to 20 percent.

**Making a perfect oval**

If you find the Elliptical Marquee tool difficult to use accurately, try using the Select>Transform Selection command. After making an approximate shape, use the Transform Selection command to pull it into the right shape.

**08** The final result shows off the main subject much better than the original and focuses your attention on the central portion of the image. Without converting to sepia, it's still possible to enhance a vintage color image using this method.

**Photoshop keyboard shortcuts**
To move a selection shape in one-pixel increments

**Arrow Up, Down, Left or Right**

**Navigator**

# Enlarging and resizing

Digital images can be made bigger or smaller to fit your target output size, but the process of resizing can reduce sharpness if not executed properly.

manipulate it

shoot it

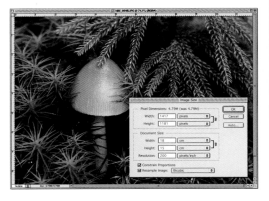

**01** All digital cameras create images at different sizes, such as 640x480 and 1800x1200, but the largest size is determined by the sensor.

**02** If you want to increase the size of a digital image in order to make a bigger print out, you first need to open the Image Size dialog. (This example measures 18x15cm.) To increase the size of the print out, make sure both the Resample Image and Constrain Proportions options are checked, as shown. Next, select the Bicubic Interpolation method from the pop-up menu, then enter the desired size in the Height and Width sections of the Document Size panel.

**03** After committing to the increase, the final stage is to sharpen your enlargement. From the Filters menu, choose the Unsharp Mask filter. In the Filter dialog box, adjust the "+" or "-" in the preview window so you can see a close-up of your image. Start with Amount 25, Radius 1 and Threshold 1, and increase the Amount value until you can see a difference. Most images sharpen well at between 100 and 150 Amount.

---

**Technical details**
Adobe Photoshop 7

**Photoshop tools**
Image Size dialog
Unsharp Mask filter
Print with Preview
dialog

**Keep in mind**
The exact method of Interpolation used in the Print Preview dialog is set within Photoshop's Preferences. Found under File>Preferences or Edit>Preferences, the Interpolation method options are in the General panel. Set it to Bicubic for best-quality results.

## print it

**Print Preview versus Image Size**

Although easier to see the final dimensions of your print out, you can't apply an Unsharp Mask Filter from within the Print Preview dialog, and you can't see a full-scale version of your image after the edit has taken place. If you want to maintain maximum quality throughout, use the Image Size method, and the Print Preview as a final check.

**04** A simpler approach to resizing can be made in the Print Preview dialog, where you can visualize the size of your image in relation to your chosen paper size. With this example, the image is too big to fit onto the target paper, so adjustments need to be made.

**05** To resize the image, deselect both Center Image and Scale to Fit Media options, and select Show Bounding Box. Next, simply pull the corner handles that surround your image until it is resized within the white rectangular paper shape. If you click within the image itself, you can even drag and drop it into position on your paper.

**06** If your paper orientation is set incorrectly, press the Page Setup button to change from Landscape to Portrait, or vice versa. When in the printer software dialog, you can choose an alternative paper size if needed.

**07** After returning to Photoshop's Print Preview dialog, your image is now displayed within a horizontal or landscape format print preview. If need be, you can make another resize before sending to print.

---

**Photoshop keyboard shortcuts**
To reset the Image Size dialog box          **Alt + Reset**

**Navigator**
Making a multi-print          p104
Print extras          p106

# Sharpening

The final but most important stage in the preparation of a digital image is sharpening. Most good image-editing packages contain an Unsharp Mask Filter, the best tool for this task.

shoot it

manipulate it

**01** Digital cameras capture deliberately soft images due to the presence of an invisible anti-aliasing filter fitted between the camera lens and the sensor. Once opened in Photoshop, bring up the Unsharp Mask Filter dialog box, as shown.

**02** All images require different amounts of sharpening, so there's no single formula that fits all circumstances. Start off by setting up the three Unsharp Mask parameters, as shown: Amount, Radius, and Threshold.

**03** By changing the Amount parameter, you are effectively increasing the contrast of adjoining pixels, and simulating sharp focus. Start off with your Amount set to 100 and increase it gradually, in increments of 25. Stop when the granular pixel pattern called "noise" appears. Most images need between 50 and 200.

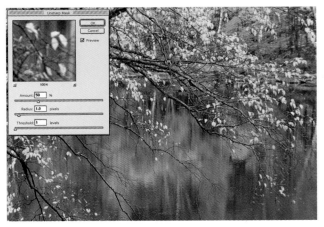

**Technical details**
Adobe Photoshop 7

**Photoshop tools**
Unsharp Mask filter

**Keep in mind**
You can't make a pin-sharp, poster-sized print from a low-resolution image file, but you can make virtually unnoticeable enlargements. If you increase the document size by up to 20 percent, you'll be hard-pressed to see any difference, as long as you apply the USM afterwards.

**04** The second control is called the Radius, and this determines the area over which the sharpening is applied. A low-value Radius, such as 2, sharpens the edges only, but a higher value, such as 10, creates a wider band of pixels that are affected. Use higher values if your image lacks perfect focus or suffers from camera shake.

**05** At a very high radius value, this image shows a characteristic increase in contrast. Excessively high values will make the image look posterized, where previously subtle colors are squeezed into visible bands.

**06** At a much-reduced radius, but with an increased Amount value, the image now looks less posterized and more natural. It's especially important to experiment with USM values if your image had a pre-set sharpening filter applied in camera.

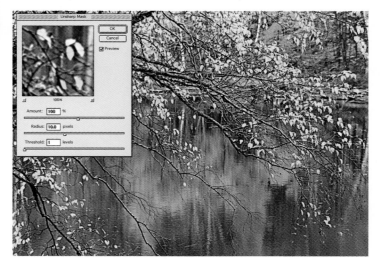

### Enlarging in stages
Rather than make your enlargement in a single command, try doing it in several stages. If you apply a very low USM filter—such as Amount 25; Radius 1; Threshold 1—after each smaller increase, you will end up with a sharper result.

**07** Set with a final value of Amount 100, Radius 10, and Threshold 1, this image was tweaked into sharpness ready to print. Excessively absorbent print media, such as watercolor paper, will require higher levels of sharpening compared to purpose-made, glossy, coated inkjet paper.

**Photoshop keyboard shortcuts**
To move USM
parameter sliders          **Arrow Up or Down**

**Navigator**
Fixing blurred photos          p44

CHAPTER FIVE

# PRINTING

# Inks

Just like the corrective stages in digital image processing, the type of printer ink you use has a profound effect on the quality of your final print.

**scan it**

**print it**

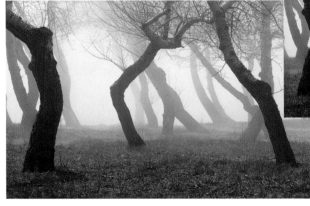

**01** If you've tried to make digital prints that mimic the look and feel of a true black-and-white photographic print, you'll know that this is far from straightforward. Images prepared in the Grayscale, Duotone, and even RGB modes all have a tendency to display a color cast in the final print.

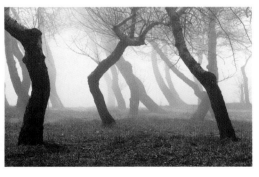

**02** Onscreen and viewed on a color-calibrated monitor, this example is a perfectly neutral, black-and-white image, but is printed with an unexpected magenta cast. The slight pinkish color spotted in the midtones suggests that a color correction needs to be made before the next print.

**03** If you're confident that your workstation is calibrated properly, and your image has been color-corrected, then the answer to the conundrum lies in the printer software controls. Color casts are frequently caused by the combination of ink and paper types, and are best removed outside Photoshop, independently from your image file. The same image printed on a different type of paper to the previous example produced a green cast.

---

090  Special Effects

**Technical details**
Adobe Photoshop 7
Epson Stylus 2000P
Printer software
Epson Photo Glossy paper

**Photoshop tools**
Gamut Warning

**Keep in mind**
Poor-quality inks and paper will always give you much less satisfactory results because they are made with cheaper raw materials. You will always get best results from using manufacturers' recommended paper and ink combinations.

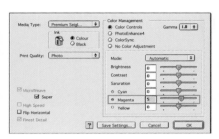

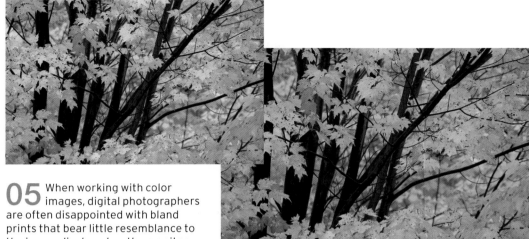

**04** Open your printer software and go to the Advanced controls, where you can access the three color sliders: Cyan, Magenta, and Yellow. Remove the color cast using these controls. In this example, green was removed by adding more of its opposite color, Magenta.

**05** When working with color images, digital photographers are often disappointed with bland prints that bear little resemblance to the image displayed on the monitor. This example is a faithful simulation of a saturated image as displayed on a computer monitor.

**06** When printed, saturated colors are often transformed unexpectedly into duller and less exciting relatives. This is caused by the innate difference in the way that transmitted light from a monitor looks, compared to reflected light from a digital print. This example simulates the printed outcome from the previous image file, and is noticeably less vivid.

### Color saturation

Professional inkjet printers use pigment inks, which are designed to last longer, but cannot produce the same kind of intense colors as standard dye-based inkjet printers. Coupled with non-shiny cotton papers, color saturation diminishes even more.

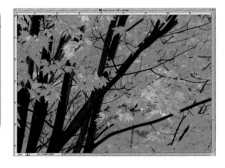

**07** In order to predict a more accurate print out, Photoshop has a useful Gamut Warning function, found under the View menu. When switched on, it will tag all colors that are unlikely to print out with the same intensity. In this example, the most vivid colors are tagged gray to show you what not to expect.

**Photoshop keyboard shortcuts**
To toggle Gamut Warning
on and off          **Shift + Command/Ctrl + Y**

**Navigator**
Color printing          p94
Test printing           p92

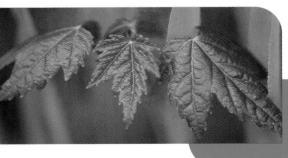

# Test printing

There's simply no point in wasting a whole sheet of paper and ink on a full-size digital print, when you can easily make a more economical test print.

## Monochrome

manipulate it

**01** All digital images need preparation before printing, so you can get the best from your paper and ink. Test printing isolates a small portion of an image, so you can judge brightness, color, and contrast. Open your image and select the Rectangular Marquee tool. Ensure that no feather value has been applied, then draw a rectangle within your image that includes both highlight and shadow points.

print it

**02** Once your selection is made, do File>Print Preview and select the Print Preview option found at the base of the dialog box, shown here in the red box. You can print any size or shape selection, as long as it doesn't have a softened, feathered edge. Next, make sure that your paper is big enough to accommodate the test, then Print.

**03** Once printed, get into the habit of marking up your test prints so it's easier to identify them side by side at a later stage. The purpose of a test is to gauge whether you've prepared your image file correctly, with both clear detail and a full tonal range. This example shows a well-prepared monochrome print with a full black, and a range of grays that exhibit all the residual image details.

---

**Technical details**
Adobe Photoshop 7

**Photoshop tools**
Marquee
Print Preview

**Keep in mind**
Always judge color prints under natural light, as colors will look different when viewed under artificial lighting conditions. If this is impractical, consider installing daylight-balanced tubes into your existing light fittings.

**04** Most first-time prints emerge too dark rather than too light from your printer, and have a characteristic muddy appearance. Prepared too dark, this example needs to be re-processed in Levels before printing again. Dark prints turn darker gray areas into blacks, and lose fine detail.

**05** This example was prepared too light and, although it displays a good range of detail, it lacks a pure black. Looking washed out and a little bit faded, this image file needs to be adjusted in Photoshop using the Curves or Levels controls.

**Test prints**
Always make your test prints on the same brand of paper that you will use for the final print out, or you won't get the result you are after. A great idea is to cut a larger sheet into several smaller portions and set up a custom paper size in your printer software.

# Color

**01** Using the same method as before, testing color images adds further complications to the process: color balance. The golden rule of color printing is to establish the correct brightness value for your image before considering color balance. This example is near perfect and shows all the delicate colors side by side, with sharp details.

**02** Heavy or dark print outs tend to look warmer and richer than the washed-out prints we're used to receiving from commercial processors. Heavy prints may look atmospheric, but they can deaden certain colors and make fine details disappear. This example loses the delicate green tones at the expense of a richer red.

**03** With most detail visible and sharp, the lighter print out looks colder and more on the blue side. Like the lighter monochrome print, this lacks strong darker tones and needs darkening down in the Levels dialog.

**Photoshop keyboard shortcuts**
To bring back the test strip selection after making a correction    Shift+Command/Ctrl+D

**Navigator**
Inks                     p90
Fixing low-contrast      p24

Printing  093

# Color balance

Strangely, unexpected colors appearing in your digital prints are not uncommon and occur due to a wide range of natural causes.

 manipulate it

**01** The easiest way to correct color imbalance is with Photoshop's Variations function. Found under the Image>Adjustments>Variations menu, the large-scale dialog box places your image in the center of a ring of different-colored variations. You can alter the balance of your original simply by clicking on the option that looks most neutral. If the differences are too slight, you can increase the change by altering the Fine>Coarse slider.

**02** Another method of correcting color casts relies less on your visual judgement and more on an objective and software-controlled technique. This example shows high-contrast, saturated colors, and an overall warm tone that looks quite acceptable.

**03** To correct the cast, open up the Levels dialog box and click on the central Midtone dropper tool. Although the Shadow and Highlight dropper tools are used to set black-and-white points respectively, the Midtone tool can correct color as well.

---

**Technical details**
Adobe Photoshop 7

 **Photoshop tools**
Variations
Levels
Color Balance

 **Keep in mind**
Color balance is entirely subjective and can change under different artificial lighting conditions. If you don't have a neutral gray reference point in your image, compare your print out to a pre-printed example such as a Kodak Graycard. Place the two side by side to compare.

**04** With the Levels dialog still open, select the Info palette by doing a Window>Info command. Make sure the top-left sector is set to the grayscale (K) readout. If another option is selected, click and hold on the tiny dropper tool icon until the list pops up. The grayscale option presents a simple and easy-to-understand scale of 0–100.

**05** Next, place the midtone Levels dropper onto a neutral gray area of your image that corresponds to a 50 percent value in your info palette. As you move the dropper over an area of pixels, the K value will detect the underlying value. If you can't find an exact 50 percent patch, zoom in closer, and try again.

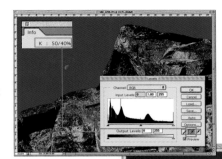

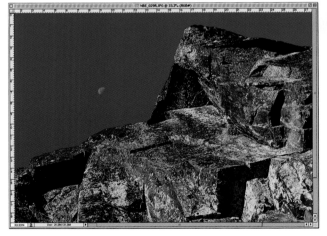

**06** Once you've discovered a 50 percent area, click down and watch how your image is automatically color corrected. If you do sample the wrong value, reset your Levels dialog by holding down the Alt key and pressing the Reset button that appears in place of Cancel.

**Spotting color casts**

You can spot color casts most easily in the neutral midtone gray areas of your image. Stronger colors and bright white highlights do not display the same hint of color imbalance and should not be relied upon.

**07** If you are confident about identifying the precise causes of your color casts, they are best removed using the Color Balance dialog. Most images shot in daylight can be corrected using the sliders with the Midtone Tone Balance option, but casts caused by artificial lighting are best removed with the Highlight Tone Balance option selected.

**Navigator**
Scanning                   p14
Fixing high-contrast       p26

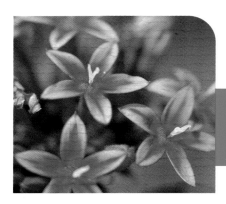

# Print papers

## The greatest advantage to digital photography is the variety of different papers you can print on.

**01** There's no straightforward way of making top-quality digital prints on an inkjet printer, especially if you rely on the automatic features of your printer software. Glossy papers, as this example shows, allow the greatest tonal range, and most vivid color saturation available.

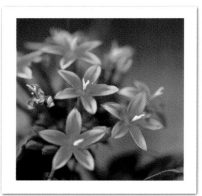

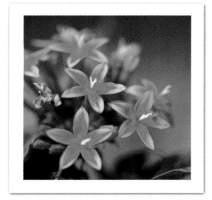

**02** Non-shiny papers are sometimes rather misleadingly called "photo paper", but are in fact matt in surface texture. Compared to glossy papers, the matt surface doesn't reproduce such a wide tonal range, despite what you can see on your monitor. Print sharpness is very high and excellent for printing fine text shapes, but color saturation is much lower than glossy media.

**03** There's no reason why all digital prints must be output on to bright white papers. Much more interesting results can be made if you vary the base color of your print media, such as in this cream example. Writing paper or off-white artists' papers offer a warmer end result, but with no white highlights. As an inkjet doesn't print white, the brightest parts of your paper will be no brighter than the base paper you use.

 **Technical details**
Epson 2000P inkjet printer
Epson Photo Glossy Paper
Epson Matte Paper

**Photoshop tools**
Hue/Saturation slider
Image Size dialog

**Navigator**
Inkjet printing    p12
Test printing    p92

 **Keep in mind**
There's no reason to prepare your image files at any greater resolution than 200ppi. You won't see any difference if you compare images printed out at 300ppi to those printed out at 200ppi. You'll even benefit from a halving of your file data size too.

**04** Textured papers, such as this artists' watercolor, will produce handcrafted prints. As this kind of paper has no special coating to support tiny ink droplets, the end result will be much less sharp. It's important when printing on this kind of paper to make your image brighter and more saturated on the monitor to counteract this dulling down.

**05** For non-standard print media, such as watercolor, writing, and cartridge paper, it's essential to drive the printer software properly. Art papers have a much more open weave compared to inkjets, and are more absorbent. Start by using the lowest-grade media type combined with the lowest printer resolution, such as 360dpi.

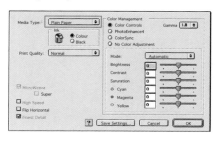

### Perfect combinations

Best-quality results are achieved when using the right combination of paper and ink. Try to use the same brand of ink and paper, as they will be designed to bring the best out of each other. A good brand to try is Epson Premium Photo Glossy paper with an Epson Intellidge inkset.

## Print problems

**01** If you see this kind of unexpected effect on your print out, then it's got nothing to do with your printer software settings. If you can see clear square pixels on your print, then the resolution of the image file is set too low. At 72dpi, pixels are visible on a print out, but if they are changed to 200dpi in your Image Size dialog box, they will not be visible.

**02** Speckled prints like this example can be produced from both high- and low-resolution images alike, but are the result of an incorrect printer software setting. Most printers can be run at 360, 720, 1440, or 2880dpi, with the 360 setting spraying the least amount of ink. This example was output at 360dpi instead of 1440dpi.

**03** Dark and unsharp prints are the result of an incorrect printer setting when too high a quality media type is selected. Surprisingly, the innocuous Media Type selector controls the amount of ink sprayed onto the paper, and therefore affects print quality. This print was output on to matt paper, but with a glossy film media type selected in error.

# Vintage printing

You don't need to fool around with expensive chemicals to mimic the look of a traditional photographic print—you can easily do it in Photoshop.

**shoot it**

**manipulate it**

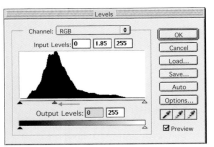

**02** It's important to prepare your image file with an identical tonal range to the print effect you are attempting to mimic. Most traditional photographic print processes have a compressed tonal range, rather than the full-on rich black, and bright whites of a digital print. Start by making your image much brighter than normal by moving the Levels Midtone slider to the left.

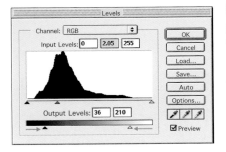

**03** Although the image is now much brighter, full blacks and bright whites are still present. Remove these extremes by manipulating the Levels Output sliders, found on the base of the Levels dialog. Move both white and black sliders to the center, until your image softens in tone.

**01** You can make a vintage effect from any kind of original, whether it's color or monochrome. Start by looking for an image that has no visible details that would anchor it to a particular era or date, as this will help maintain the illusion.

---

**Technical details**
Nikon D100 digital SLR
Adobe Photoshop 7
Epson 2000P
pigment printer
Somerset Velvet
Enhanced paper

**Photoshop tools**
Levels
Hue/Saturation
Gamut Warning

**Keep in mind**
If you choose to prepare an image with delicate colors, there's a chance that these will not reproduce well on a standard, four-color inkjet printer. You can predict your likely result by selecting the View>Gamut Warning control. Any colors that are unlikely to print are displayed with a gray marker color.

**04** Now with a much softer appearance, the original image looks like a slightly faded slide. This example of low-contrast color can be a good stopping off point in this project, but the real task is to tone the image with a single color.

**05** To drop a single color tone on your image file, do an Image>Adjustments>Hue/Saturation command. Once the dialog box is open, drag it to one side and click the tiny Colorize button, found at the bottom right corner.

**06** By default, the Hue/Saturation dialog will produce a fully saturated result when the Colorize button is checked. The first version of your image will look very bright, intense, and not particularly convincing.

### Pigment on cotton

Try printing this kind of image on a pigment printer with special cotton paper, such as Somerset Velvet Enhanced. The duller tonal range of pigment inks and the tactile nature of cotton media perfectly complements the vintage feel of this technique.

**07** Once you've decided on the exact color by moving the Hue slider, reduce the Saturation down to a minimum. Aim for a lighter, washier kind of effect rather than vivid color, as the latter will not print as well as it appears on the monitor. Finally, alter the Lightness slider until the image looks ethereal and delicate.

**08** The final result mimics the look of a selenium-toned black-and-white photographic print.

**Navigator**
Creating emphasis       p80
Making cut-outs         p82

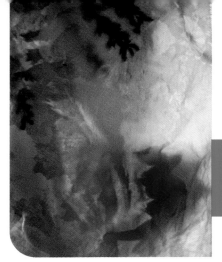

# Borders and edges

You can add a final finishing touch to your digital image by drawing a border or decorative edge.

scan it

**01** Start off by preparing your image as normal, and make sure that you've set the correct resolution for your target output device—72ppi for web use or 200ppi for inkjet printer use. Don't apply the final stage of the Unsharp Mask filter until you've completed one of these edge techniques.

manipulate it

**02** Do Image>Canvas Size and open the dialog box. At the base of the dialog, make sure you've clicked on the central square in the Anchor box. This determines the center point for the forthcoming image expansion. Next, increase the Width and Height values by 2cm each.

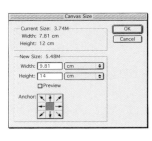

**03** Click OK, and return to your image. Notice that a new white perimeter area has now been created around the image. If your example doesn't look white, do Edit>Undo and change the current Background color to white. Extra Canvas area is created from new pixels, which will increase your file size.

### Edge effects

Various edge effects can be added via the printer software, rather than added permanently to your image file in Photoshop. However, there's much less choice of color when selected in the printer software, and you can't see a preview, either.

**Technical details**
Adobe Photoshop 7

**Photoshop tools**
Canvas Size
Stroke

**Navigator**
Print extras          p106
Using antique mounts  p102

**Keep in mind**
When you change Canvas Size, you effectively increase the document size too. Double check that your new image doesn't become too big to print out by doing a File>Print Preview command.

**04** Next, choose the Dropper tool from the toolbox and zoom in close to your image. Look for a dark tone which is still a recognizable color, but not full black, and not a midtone gray. Click on this and set it as your current foreground color.

**05** If you're happy with your selection, click on the tiny double arrowhead at the top-right of your Foreground/Background color patches in the toolbox. This will swap the current Foreground color with the current Background color. Pressing X on your keyboard has the same effect.

**06** Return again to your Canvas Size dialog box and, with the new darker tone as your background color, make a further increase in size. Add another two centimeters to both Width and Height values, and press OK.

**07** The final result mimics the look of a colored mountboard, with a white inner border surrounded by a darker color, which enhances the original image. By sampling a color from the image itself, you guarantee color continuity.

**08** You can make a black border to form an outline around an image that don't have a dark edge. Set the current Foreground color to Black and then do an Edit>Stroke command. Set the Width as 8 pixels in the Center Location, with Normal Blending mode and 100 percent opacity.

**09** Click OK and watch the thin black line appear around your image. If the line is too thick, do Edit>Undo, then repeat the Stroke command with a smaller pixel width. If you are working on a high-resolution file, you may encounter a smaller than intended edge.

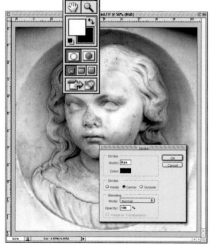

**Photoshop keyboard shortcuts**
To reset Black and White as current
Foreground/Background colors          **D**
To swap current Foreground
and Background colors                  **X**

# Using antique mounts

Armed with a simple flatbed scanner and a page from an old photograph album, you can easily make a decorative mount for your digital portraits.

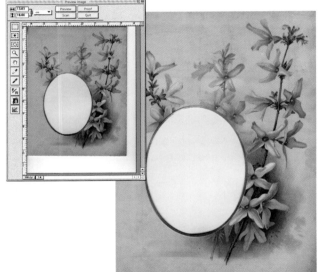

## scan it

**01** Start by placing a decorative mount on your flatbed scanner and set the scanner controls to capture at 200dpi, in RGB color mode. Even if the mount is mostly a single color or tone, it's better to capture in the RGB mode rather than Grayscale.

### Color modes
If your paste command drains your image of its color, then you are most probably placing it in a grayscale-mode document. The destination document defines both the color mode and the resolution of any element pasted in from another image.

## manipulate it

**02** After placing your mount on the scanner bed, place a sheet of brightly colored paper or card on top of it, so it shows through the aperture. On this example, a sheet of bright blue card was used, and can be seen through the oval hole, which helps a future stage of cutting out.

**03** Once scanned in, make all the necessary tonal adjustments using the Levels commands, and retouch all physical blemishes using the Clone Stamp tool.

**Technical details**
Umax Powerlook flatbed scanner
Adobe Photoshop 7

**Photoshop tools**
Hue/Saturation slider
Transform Selection

**Navigator**

**Keep in mind**
You need to prepare both mount and portrait image with the same resolution beforehand, or you'll be faced with two very different-sized items. Although it's possible to scale a layer up or down in size, you'll get much sharper results if this is kept to a minimum.

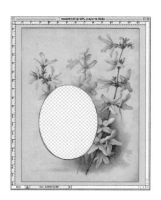

**04** Rename your background layer by double clicking on the layer icon and calling it "Layer 1". This allows you to cut holes into your single pixel layer. Select the Elliptical Marquee tool and draw an oval selection around the area you want to cut away. Use the Select>Transform Selection to make an exact fit around your shape.

**05** Next, do Edit>Cut to remove the unwanted bright oval area. Your Layers palette should look like this, and you should see a checkerboard pattern, denoting an empty image area. If there are any leftover blue pixels from the cut, remove these using the Eraser tool.

**06** Next, prepare your original image for insertion into the mount, by scanning or downloading from your digital camera. Make all contrast and color corrections before proceeding to the next stage. Do a Select>All command, followed by an Edit>Copy.

**07** Click back into the mount image window and Edit>Paste. This will introduce the portrait image into the mount image document. Drag the portrait layer beneath the mount layer, until it only appears through the hole you've created. You can alter the size and shape by using the Transform controls.

**08** Your Layers palette should look like this.

**09** Next, click on the Mount layer and change the color so that it complements the photographic image. Select the Colorize option in the Hue/Saturation dialog box, then move the Hue slider until your mount changes to a suitable color. Reduce the color intensity by using the Saturation slider, as shown.

**Photoshop keyboard shortcuts**
To invert a selection — Ctrl/Command + Shift + I
Copy — Ctrl/Command + C
Paste — Ctrl/Command + V

# Making a multi-print

You can easily make a print out that includes more than one image using Photoshop.

manipulate it

**01** Open up your first image and rename the Background layer by calling it "Layer 0". Create a new layer and Edit>Fill this with 100 percent background white. Drag the image layer above the empty white layer. Separating images from a white background will make it easier to introduce other images at a later time.

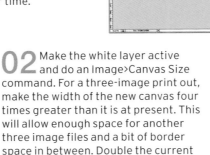

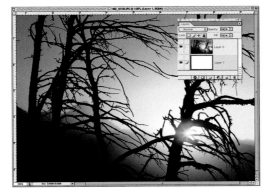

**02** Make the white layer active and do an Image>Canvas Size command. For a three-image print out, make the width of the new canvas four times greater than it is at present. This will allow enough space for another three image files and a bit of border space in between. Double the current file height.

### Naming layers

There's nothing more frustrating than trying to work out which part of your work in progress corresponds to which layer, if they are carelessly labelled. Name each layer with a word that fully describes its content.

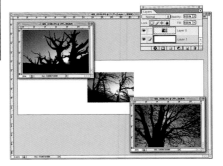

**03** Organize your desktop so you've got all three source images open. Each of these images must be prepared with the same pixel dimensions, or they will shrink or expand when copied across. Use your Image Size dialog to resize.

---

**Technical details**
Nikon film scanner
Adobe Photoshop 7

 **Photoshop tools**
Guides
Layers
Image Size

 **Keep in mind**
Even though elements of your imaging project may appear to be placed in the right part of your document, you should zoom in closer just to make sure. When viewed at less than 100 percent, your computer monitor won't be able to show slight misalignments, so it's essential to get closer.

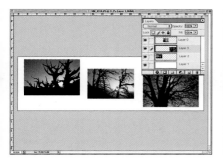

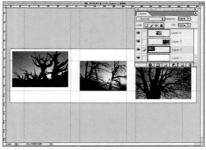

**06** Select the Move tool and click on the layer that corresponds with the image you want to move. When each image has been placed on or near the guides, zoom in to 100 percent. To make each image fit perfectly, do Edit>Transform, then push and pull the corner handles until the image fits snugly within the blue guidelines, as shown. Repeat this for all three images.

**04** Starting with the first image, Select>All, then Edit>Copy. Click into the white canvas image and Edit>Paste. Repeat the process for the second image and then close all image windows on your desktop, except for your working project. Your Layers palette should have four distinct layers, as shown.

**05** From the View menu, select Show Guides and then click drag a blue guideline from the top ruler margin of your image window. These blue lines will help you to arrange each image precisely. Use your rulers to place the guides at equal spaces.

**07** Next, link all three layers. Click on any layer that isn't the white background, then create a linked chained icon by clicking on the empty box next to the Eye icon in your Layers palette. Finally, do a Merged Linked command to create a single layer.

**08** The image is now ready to print, but if you want to create a better synthesis between three very different originals, then you can apply a simple toning effect. With your now single Images layer active, do an Image>Adjustments>Hue/Saturation command and click on the Colorize button, as shown. This will apply the same kind of tone to all three images on the layer.

**print it**

**09** The finished print was output on to a special custom-sized sheet of inkjet paper that fell within the maximum width accepted by the printer. Panoramic prints are an effective way to emphasize your work.

| **Photoshop keyboard shortcuts** | |
| --- | --- |
| Free Transform | Ctrl/Command + T |
| Transform without distortion | Shift + drag a corner handle |
| **Navigator** | |
| Creating emphasis | p80 |
| Enlarging and resizing | p84 |

# Print extras

There's no need to import your digital photos into a desktop publishing program if all you want to do is add some simple text or collate thumbnails for an index.

Devils Canyon, USA, 2003

## Printing a caption

**manipulate it**

**print it**

**01** You can easily annotate your digital files by using Photoshop's File Info function which can even be printed out. Open your image file, do File>File Info, and work in the General Section. In the Caption field, type in the information you want to print beneath your image.

**02** Next, go to Print with Preview, and select the Show More Options box. Return to the preview window, and double-check that your printed image area is well within the size of the selected paper. If it's edge-to-edge, the caption won't print, so leave an empty space at the bottom edge. Select the Caption option, and notice a faint gray line appear, denoting the position of the caption.

**03** Once output, your caption will be positioned centrally under the bottom edge of your image. There's no choice in font size or color, but for a quick and easy-to-read reference, this is ideal. Simply deselect Caption to prevent it appearing on future prints.

---

**Technical details**
Adobe Photoshop 7
Epson Stylus Photo 1290

106  Special Effects

**Photoshop tools**
File Info
Contact Sheet II
Picture Package

**Further info**
If the exact Picture Package layout you want isn't listed, you can actually design your own. The measurements are saved in a simple text file and all you need a basic text editor, such as Word Pad or Simpletext. Photoshop Help provides detailed instructions on how to do this.

# Printing a picture package

**manipulate it**

**01** You can make a multiple print out from a single image file, using Photoshop's Picture Package function. Do File>Automate>Picture Package. From the Document section, choose your paper size, layout, and print resolution. In the Label section, you can add your own caption, too.

**print it**

**02** Once your Picture package command is completed, it creates a new document, ready for print out. Make sure you choose a larger paper size to print on, or your image may be clipped at the sides. Finally, cut each image out using a sharp rotary trimmer.

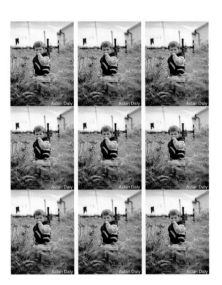

# Making a cover sheet

**manipulate it**

**01** Collections of image files on CD can be difficult to browse through, but you can make this much easier by printing out a reference sheet. Organize your work into a single folder, then do File>Automate>Contact Sheet II. Choose a document size to match the dimensions of your CD case, and decide on the number of columns and rows you need to get every image on a single sheet.

**print it**

**02** When printing out, choose the Crop Marks option in your printer software, so the small document can be cut out at exactly the right size. The thumbnails are still recognizable at up to 50 per CD cover.

## Printing out filenames

The most frustrating activity of searching for, and retrieving image files, can be made a lot easier if you print out the document file name on your CD contact sheet cover. Get into the habit of using economical words to describe the subject of the document, and if there is more than one variation, use numbers as well.

**Navigator**

Inkjet printers        p12
Print papers          p96

# Saving and archiving

What seems like the most insignificant stage in an editing project, could in fact have severe repercussions on your image quality.

## Poor compression

JPEG compression is a lossy routine, meaning that image quality will visibly deteriorate each time the file is saved. In this example, the original image file is presented on the left half of the Save For Web dialog. On the right half is a preview of the destructive pattern-like effects caused by saving as a low-quality JPEG.

## Better compression

In all image-editing packages, the JPEG saving option includes a quality factor described by a 0–10 or 0–100 scale. Virtually unnoticeable compression occurs at around 80 or 8, but much data is saved in the process. In this example, the image on the right is compressed, and still looks top-quality.

## Highest quality

The best file format to save your image file in is a TIFF. TIFFs are cross-platform, are accepted by all leading image-editing programs, and won't destroy image quality. In Photoshop 7, the new layer-compatible TIFF is less universal and not a realistic alternative to the Photoshop (PSD) format. TIFFs can also be compressed, but maximum quality is achieved by setting your Options dialog, as shown. Choose your platform in the Byte Order section.

**Technical details**
Adobe Photoshop 7

**Photoshop tools**
Color Settings
Save As

**Digital camera color space**
Many better digital cameras offer the function of shooting in one or more color space, so you can work seamlessly within different workstations. Most cameras shoot in the SRGB color space, but better ones can shoot in the more universal Adobe RGB (1998) space.

# Compressing multiple documents

If you want to send your image files via email or FTP, it's a good idea to package them into an archive file using Stuffit. Save your files as TIFFs or JPEGs, then place them in a single folder. Drag them into Stuffit, and watch the archive form. This single file, created with the .sit, .hqx, or .zip file extension will pass through most network and internet restrictions.

# Tagging your image

Most Photoshop users will happily accept the default color settings without thinking twice. Yet if your image is squeezed from a big color space to a smaller one, you'll start to lose quality. This example shows Photoshop's default Color Settings, which should not be used.

# Setting up the color space

Go to File>Color Settings, and pick the Custom Mode from the drop-down menu. Next, check the Advanced Mode option and match each drop-down, as shown. These settings are the most universal, and least likely to cause conversion issues in future working projects. For the Gray Gamma setting, choose 2.2 if you are Windows PC user, and 1.8 if you are a Mac user.

# Saving with a profile

When prompted to name your image during the process of making a File>Save As command, you will now notice an additional option at the bottom of the Save As dialog box. In the Color section, select Embed Color Profile: Adobe RGB (1998) option. This setting is incorporated into your file, and can be used for precision color management.

# Saving a layered file

If you want to preserve the individual layers of a complex work in progress, you need to save it in a special format. Only the Photoshop format offers this function, and allows you to save a file with unlimited layers. Once saved and re-opened, your layers will appear in exactly the same place where you left off.

**File extensions**

The three- or four-character ending to a filename is known as a "file extension". This enables your computer, and your image-editing application, to recognize the file, and work with it. File extensions are essential for cross-platform file sharing.

**Navigator**
Digital workstation    p8
Digital cameras        p10

# Glossary

## A

**Aliasing** · The inability of square pixels to describe a curved shape or outline.

**Artifacts** · Error pixels produced by excessive processing or compression.

## B

**Bitmap mode** · A two-color image mode used to create and store basic line art images. Bitmaps result in tiny file sizes, but allow little processing.

## C

**Canvas** · The addition of extra blank areas to allow for added elements.

**Channel** · Each color mode is constructed from component colors, organized by channels.

**Cloning** · The process of copying pixels from between areas of an image.

**Color space** · Images can be created in a number of different color spaces, such as Red, Green, Blue (RGB), and Cyan, Magenta, Yellow, and Black (CMYK). These different spaces package the image for output.

**CMYK** · Cyan, Magenta, Yellow, and Black mode is used for preparing images for lithographic reproduction. CMYK images are 25 percent larger than RGB.

## F

**Feathering** · Softening of edges. Feathered edges are determined by width which is measured in pixels.

**Film scanner** · A capture device for creating a digital file from exposed photographic film.

**Flatbed scanner** · A device for digitizing 2D artwork, such as prints, drawings, and magazine pages.

## G

**Grayscale mode** · A 256-tone monochrome image mode, made from pure black-and-white, and 254 grays.

## H

**Halftone** · A method by which artwork is converted into a series of tiny dots which, when viewed from a distance, merge into one another.

## I

**Inkjet printer** · Inkjet quality is related to the amount of inks used, and the size of ink drop.

**Interpolation** · A process that adds new pixels to an existing image file to enlarge it. New pixel color is worked out by averaging adjoining colors.

## L

**Lab image mode** · A theoretical color space used for processing digital images in. The Lab mode is the largest color space and will not clip or convert.

**Layered image** · A work-in-progress image that remains separated into floating components. Layers also allow for blending and opacity effects.

**Levels** · A universal tool for adjusting the tonal range and brightness of an image. Levels are based on an objective count of the image's pixel brightness range.

**Lossless compression** · Both TIFF and GIF formats compress data using a lossless routine: i.e. no cumulative damage is applied to the image file.

**Lossy compression** · The JPEG format compresses data using a lossy routine, meaning that each time an image is resaved in the JPEG format, the image quality will deteriorate.

## M

**Masking** · A process whereby parts of an image are protected by a mask, and any subsequent editing is therefore limited to other areas.

**Megapixel** · Used to identify the pixel count in units of one million.

## P

**Pictrographic printer** · A high-resolution digital device that uses special donor and receiving paper, and needs only water to operate.

## R

**RGB** · The RGB image is constructed from three color channels: red, green, and blue. All images are best archived in this color mode.

## S

**Selecting** · Creating a fenced-off area inside your digital image, inside which future editing can be restricted.

## U

**Unsharp Mask** · Describes a filtering routine for improving sharpness. The USM filter is essential for minimizing the softening effects of anti-alias filters used in digital cameras.

# Index

# Acknowledgments

The author would like to thank the following for their advice and guidance throughout the preparation of this book:

Leonie Taylor
Commissioning editor at RotoVision

Nigel Atherton
Editor, *What Digital Camera* magazine

Nick Merritt
Editor, *Digital Camera* magazine

Chris Dickie
Editor, *Ag* magazine

Phillip Andrews
Author and co-founder of Photocollege website, http://www.photocollege.co.uk

The staff and students at the Art, Design, and Media department at East Surrey College, Redhill, a Center of Vocational Excellence for Digital Media.